IMAGES
of America

MILTON
ARCHITECTURE

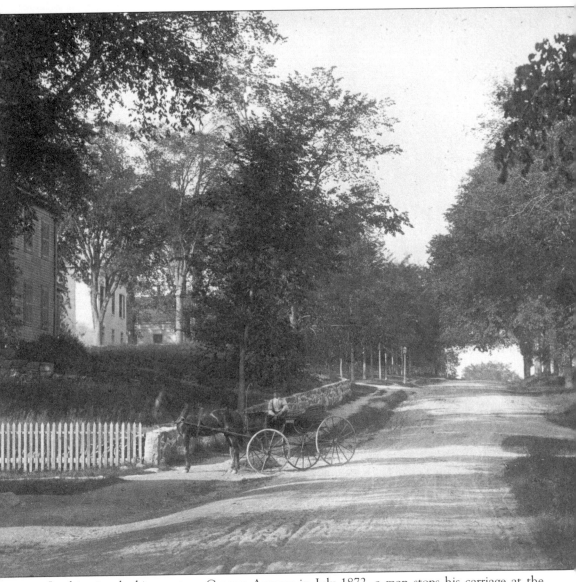

In this view looking east on Canton Avenue in July 1872, a man stops his carriage at the junction of Thacher Street on the left and Highland Street on the right. Now known as the Milton Centre Historic District, the area has also been known as Academy Hill, after the first building of Milton Academy, which can be seen on the far left. Starting on the left are the Unitarian Convalescent Home (the former academy building), the façade of the First Parish in Milton, Unitarian, and the Milton Town House, built in 1837 at the crest of the hill. This bucolic scene with mature shade trees was typical of how rural Milton remained until after World War I, when massive development took place. (Courtesy Milton Historical Society.)

Oh! Those blessed times of old! With their chivalry and state;
I love to read their chronicles, which such brave deeds relate;
I love to sing their ancient rhymes, to hear their legends told.
But Heaven be thanked! I live not in these blessed times of old!

—Frances Brown

IMAGES
of America

MILTON
ARCHITECTURE

Anthony Mitchell Sammarco and Paul Buchanan

ARCADIA

First printed in 2000.

Published by Arcadia Publishing,
an imprint of Tempus Publishing, Inc.
2 Cumberland Street
Charleston, SC 29401

Printed in Great Britain.

Library of Congress Catalog Card Number: 00-107745

For all general information contact Arcadia Publishing at:
Telephone 843-853-2070
Fax 843-853-0044
E-Mail sales@arcadiapublishing.com

For customer service and orders:
Toll-Free 1-888-313-2665

Visit us on the internet at http://www.arcadiapublishing.com

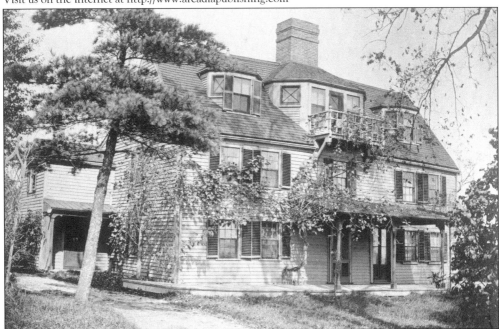

The Tucker House originally stood on Brush Hill Road opposite Robbins Street. It was built
c. 1670 and is the oldest house that was built in Milton. (The Capen House, built before 1658,
was built in Dorchester and moved in 1909 to Hillside Street in Milton by Dr. Kenneth T.G.
Webster.) Occupied by generations of Tucker family members, the 17th-century Tucker House
was "modernized" in 1875 by Susan W. Clark after a quaint house in the Old Prussian town of
Goslar. The house had three dormers and a balcony added to the roof as well as a new door
knocker from Goslar. The updating of older houses to reflect current architectural tastes has
often changed houses beyond recognition. (Courtesy Milton Public Library.)

CONTENTS

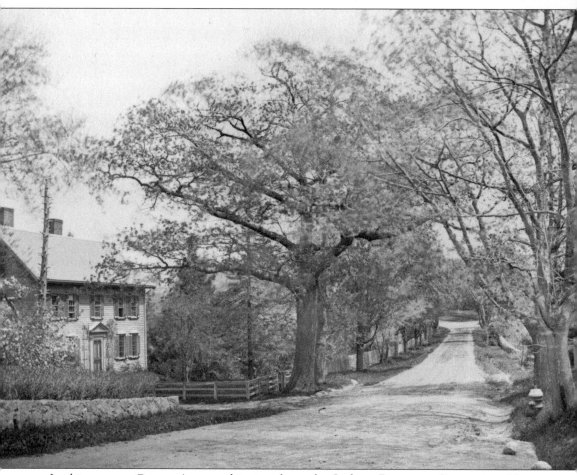

Looking east on Canton Avenue, this view shows the Crehore-Davenport-Sutermeister House, built 1781 at 1631 Canton Avenue. The property included the first commercial greenhouses in town and a chair factory, operated by Lyman Davenport and John Shepard Crehore. The noted chronicler of Milton at the turn of the century was photographer Margaret "Daisy" Sutermeister (1875–1950), whose collection of Milton photographs is an important record of suburban life in the late 19th century. On the right is the estate of the Bartol Family. With stone walls, mature shade trees, and an abundance of greenery, this stretch of Canton Avenue still retains its rural aspect a century later. (Courtesy Milton Historical Society.)

Deus Nobis Haec Otia Fecit
God has given us this tranquility—or these pleasant things.

—Virgil

INTRODUCTION

Architecture has been described as the science or the profession of designing and constructing buildings. However, it involves much more. One often views architecture as an important aspect of our daily lives, with the style and design of town buildings, schools, places of worship, and residences as unique examples of an architect's and our own personal expression, and consequently the way in which we view our town.

Milton, Massachusetts, once a part of Dorchester, was founded in 1640. It was originally known as Unquety, the term used by the Neponset tribe of the Massachusetts Indians as "lower falls" versus Unquetyquisset, meaning "upper falls," or the present area known as Mattapan. The town was a rural countryside with small mills along the Neponset River. Milton has a range of the Blue Hills in the southwest part of town (the highest being 710 feet above the high water mark), from which one has spectacular views of Boston and Massachusetts Bay to the east, the peninsula of Cape Cod to the south, and the Wachusett Mountain to the west. Describing the town in 1839 for his *Historical Collections of Every Town in Massachusetts*, John Warner Barber said that "Milton is adorned with some pleasant country seats, and contains at the two falls [Lower Mills and Mattapan], and at the bridge where the Neponset meets the tide, manufactories of cotton, paper, &c." For the first century after its founding, the architecture in Milton was considered post-Medieval, or as we now refer to it as First Period construction, with houses built in the English building traditions of East Anglia or west country framing well known to the Puritans. Although it was not until the late 18th century that one could really classify any significant "American" influences on architecture, the interpretation of the neoclassical forms popular in England became known in America as Federal, which would successively be followed by the Greek Revival, Gothic Revival, and a plethora of Victorian styles that included the Italianate, Stick, Romanesque, Queen Anne, and Colonial Revival styles. Each of these architectural styles was the reflection of an architect's or builder's idea of how designs could be built or adapted at the time.

Today, Milton's architecture is represented by a wide spectrum of styles from the earliest houses in town, the Capen House (before 1658) and the Tucker House (*c.* 1670), to the Daniel Vose House, or as it is known today, the Suffolk Resolves House. Other notable houses include the Isaiah Rogers–designed Capt. Robert Bennet Forbes House; the William Ralph Emerson–designed Eustis House as well as his own residence, the Emerson House on Randolph Avenue. The new "trophy houses" of the last decade were built not just to impress, but to express a new twist on architecture and the clients' obvious desire for vast living space.

The Milton Historical Commission—with the work of Edith Clifford, who serves as its preservation consultant—has been able to identify and designate historic districts in town. These are the Milton Centre, the Milton Hill, Scott's Woods, Brush Hill, and Railway Village

Historic Districts. With identification of significant architecturally important residences, churches, buildings, and other contributing factors to these districts, the designation by the Massachusetts Historical Commission of a historic district ensures that the architectural aspects of the town remain protected for our descendants. In this vein, this photographic book on Milton architecture, with the majority of the photographs from the collections of the Milton Historical Society and the Milton Public Library, was written in the hopes of assisting the reader in the identification and exploration of each of the architectural styles represented in the town and to expand upon the known history and development that adds to the fascinating place we call home—Milton, Massachusetts.

The Art of Building faithfully portrays the social history of those people
To whose needs it ministers but cannot get beyond those boundaries
—Calvert Vaux

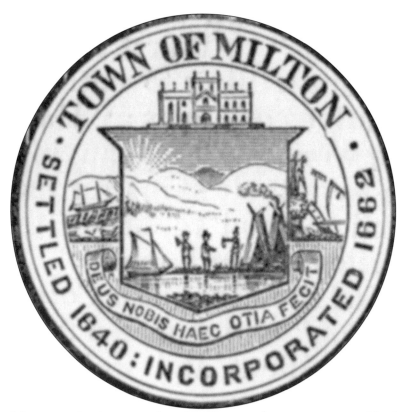

The seal of the town of Milton was adopted at the annual town meeting on March 4, 1878. Prepared and designed by a committee composed of Rev. Albert Kendall Teele, James Murray Robbins, and Charles Breck, the seal has the Neponset River with a small sailing vessel upon it, with Puritan settlers trading with members of the Neponset tribe of the Massachusetts Indians. The sun rises above the Blue Hills, and to the right of the shield appears a plough, scythe, rake, and a sheaf of wheat and a stalk of corn—emblems of agriculture. On the left appears a shallop on the stocks—an emblem of shipbuilding. The crest is a replica of Milton Abbey in Milton Abbas, Dorset, England from which the town's early settlers emigrated.

One

TOWN ARCHITECTURE

The town of Milton was founded in 1640 and set off from Dorchester, Massachusetts, as an independent town by the consent of the General Court in 1662. Governed by town meeting, a form of government established in Dorchester in 1635, the town was to remain relatively rural well into the early 20th century, although only 7 miles from Boston. However, in the last century, Milton has seen tremendous changes, beginning with the boom years following the Civil War, when families seeking country retreats purchased large parcels of farmland. These vast summer estates were laid out by the Forbes, Cunningham, Hollingsworth, Eustis, Wolcott, Peabody, Kidder, Touzalin, and Rotch-Lamb families. In some cases, the estates would survive until relatively recent times, when they were either subdivided for residential development or designated as protected lands.

Milton's Town architecture was to evolve from the meetinghouse on Academy Hill (now First Parish in Milton) to the Old Milton Town Hall, a Greek Revival building built in 1837 on the site of the present Lira Band Stand in front of the town hall. With the split between the First Church, when it accepted Unitarianism, and the creation of the First Congregational Church, whose members had withdrawn from the church, the separation of church and state took place, and all town meetings and related business was to be conducted in Milton Town Hall. The first structure survived until 1878, when the architectural firm of Hartwell & Tilden designed a Romanesque Revival brick and terra-cotta town hall, both partners being summer residents of Milton. This impressive town hall would host annual town meetings until 1971, a year after the present town hall was built and the former was demolished. The present Milton Town Hall was designed by the architectural firm of Richard C. Stauffer & Associates of Washington, D.C., and built in 1970 by Dunphy & Craig.

Town architecture also includes the Milton Public Library, which was founded in 1870. The Central Library on Canton Avenue was designed by the architectural firm of Shepley, Rutan, & Coolidge and was built in 1902. An impressive classical design in the Beaux Arts tradition, it has paired Ionic columns flanking the entrance with monumental Palladian windows in each of the reading rooms. The other branches, the East Milton Branch and the now closed Kidder Branch at Mattapan, were designed by Eliot T. Putnam and built in 1931 and 1929, respectively.

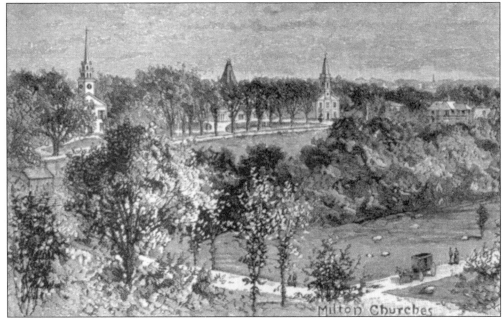

An etching of Milton Centre in 1876 from Highland Street shows the Milton Town Hall in the center flanked by the First Parish in Milton, Unitarian, on the left and the First Congregational Church on the right. The division of church and state was solidified when a town hall was built between the two meetinghouses in 1837, replaced in 1878 by a brick Romanesque Revival building designed by Hartwell & Tilden and built by William Poland & Son of Boston. On the upper right is the Hiram Tuell House on Canton Avenue. The property on the lower right was owned by A.E. Touzalin (1842–1889), whose house was designed by William Ralph Emerson and built in 1885 (now the site of the Milton police headquarters and the Milton Hospital.)

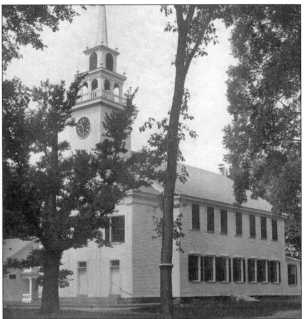

The First Parish in Milton, Unitarian, was built in 1787 as the fourth meetinghouse on the site. It is the oldest religious organization in Milton, dating from 1678, when 12 members of the Dorchester meetinghouse signed a covenant. Originally built facing Thacher Street, the meetinghouse was turned in 1835 to face Canton Avenue. The first meetinghouse was at the junction of Adams Street and Churchill's Lane and moved to its present location in 1728. (Courtesy Milton Public Library.)

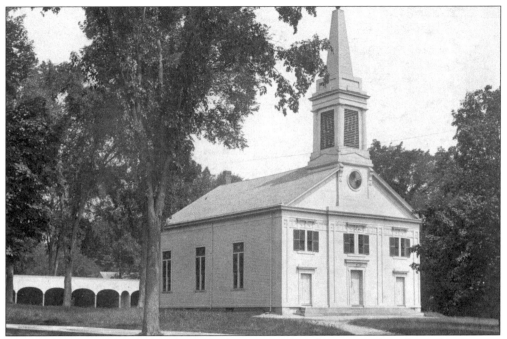

The First Congregational Church was built in 1834 when former members from what became the Unitarian Church established an "evangelical" church in Milton. Built on land donated by Nathaniel Tucker just east of the original meetinghouse, the church is an example of a classic New England meetinghouse. (Courtesy Milton Public Library.)

The Old Milton Town Hall (right) was a Greek Revival building built in 1837 on the crest of Academy Hill between the Unitarian and Congregational churches. A simple wood-framed Greek Revival building with Doric corner pilasters, its only ornament was the pedimented façade facing Canton Avenue. Shown in December 1867, the town hall was demolished in 1878, when a more modern Victorian building designed by Hartwell & Tilden was built on its site. Note that the clock of the First Parish church (center) is in the pediment rather than the base of the spire as it is today. The horse sheds are visible on the far left. (Courtesy First Parish in Milton, Unitarian.)

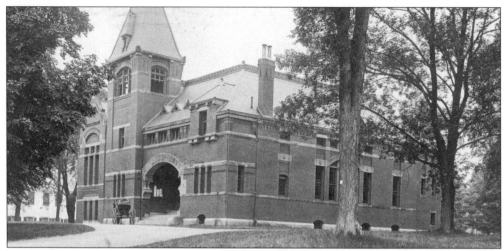

The Milton Town Hall was built in 1878 by the Boston architectural firm of Hartwell & Tilden, which was a partnership of Henry W. Hartwell (1833–1919) and George T. Tilden (1845–1919) between 1877 and 1879. After 1879, Hartwell—who had apprenticed as an architect with C.H. Hammat Billings—was associated with the firm of Hartwell, Richardson, & Driver. The town hall was a red brick and granite Romanesque Revival building. It had a center tower projecting from the façade and terra-cotta molded detailing on the roof ridge and tower. Unfortunately this elaborate Victorian building was demolished in 1971 after the present town hall was completed. (Courtesy Milton Historical Society.)

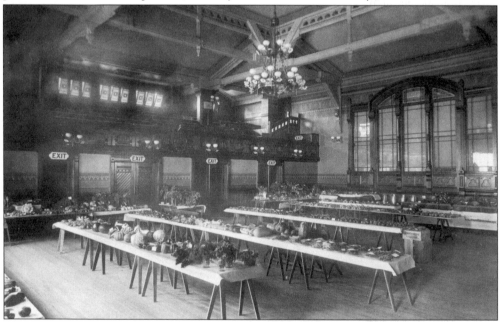

The interior of the town hall had quarter-sawn oak woodwork, leaded and stained-glass windows, and an enormous gas fixture in the center of the ceiling. The town hall, as described in 1887, was built with "solid walls, heavy roof-trusses, and the general aspect of completeness and durability." The cove ceiling had carved trusses with decorative detailing and pendills. The committee on Home Gardens of the Milton Education Society held an exhibit here in September 1911 of locally grown fruit and produce. (Courtesy Milton Public Library.)

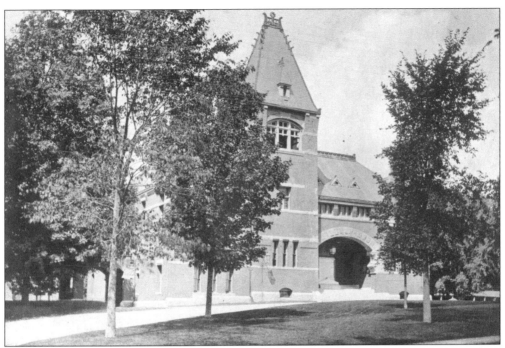

This view shows the façade of the Milton Town Hall from Canton Avenue. Its rich details of a wide Romanesque archway with rough-hewn granite keystone blocks, a slate roof with copper detailing, red brick, and terra-cotta and granite construction made for an impressive town building. (Courtesy Milton Public Library.)

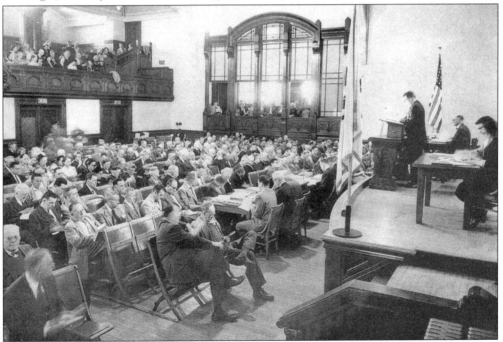

Members of Milton Town Meeting were photographed in 1955 as reports were read at the Milton Town Hall.

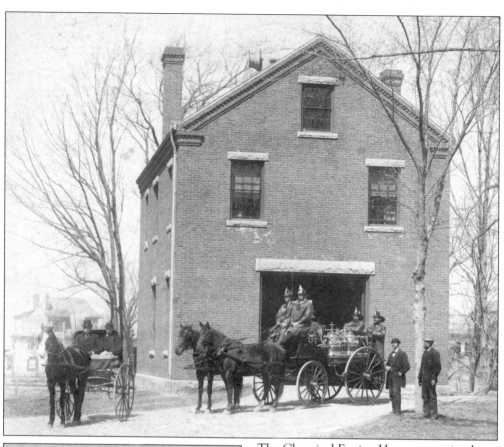

The Chemical Engine House was a simple red brick and rough-hewn granite lintel building that was built in 1881 by J.H. Burt & Company of Mattapan. Chemical No. 1, proudly displayed in front of the engine house, was the first fire engine in Milton. It was purchased in 1881. The house of George T. Tilden, of the architectural firm of Rotch & Tilden, can be seen on Walnut Street on the far left. (Courtesy Milton Historical Society.)

John H. Burt (1827–1907), in partnership with his brother George Burt as J.H. Burt & Company on Blue Hill Avenue in Milton, founded a building and contracting concern that was among the leading firms of its kind in Boston. Burt, whose house was at the corner of Brook Road and Thacher Street, built speculative houses on Oakland Street in Mattapan and off the Blue Hills Parkway in Milton. Burt served as a member of the board of selectmen for many years.

George L. Burt joined his brother in the J.H. Burt & Company, which had been founded in 1850. George Burt lived in Mattapan and served his constituents as state representative and later as state senator in 1884 and 1885.

J.H. Burt & Company of Mattapan built the Central Firehouse in 1888. Town of Milton firemen pose *c.* 1920 with a chemical engine on the right and a hose wagon with horses borrowed from Thacher Farm, as horses had already been phased out of use for the fire department. A decidedly Romanesque Revival firehouse, it had classical details such as the Palladian window in the frontal gable, and an asymmetrical bell tower. (Courtesy Milton Historical Society.)

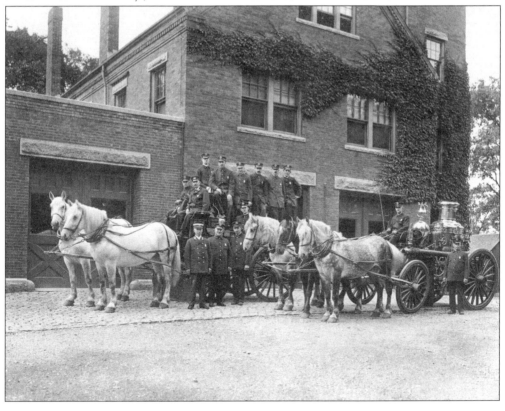

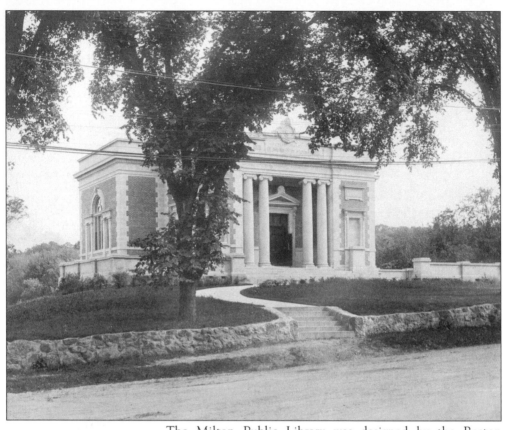

The Milton Public Library was designed by the Boston architectural firm of Shepley, Rutan, & Coolidge and built in 1902 at the corner of Canton Avenue and Reedsdale Road. The building committee for the new library consisted of Messrs. Hollingsworth, Kidder, Apthorp, Rogerson, and Tucker. Built by Norcross Brothers, the library is an impressive classical Beaux Arts design, with paired monumental Ionic columns flanking the entrance, corner quoining, and niches on either side—all surrounded by a limestone wall. Above the entrance, the seal of the town of Milton is carved in limestone and is capped by an amphimion. (Courtesy Milton Historical Society.)

Charles Hercules Rutan (1851–1941) was a partner in the Boston architectural firm of Shepley, Rutan, & Coolidge, the successor firm to H.H. Richardson, of whom Rutan was a son-in-law. Having studied architecture with Gambrill & Richardson, he founded an architectural firm with partners George Foster Shepley (who was married to Julia Richardson) and Charles Allerton Coolidge (who was married to Julia Shepley). It became one of the premier architectural firms in this country. (Sammarco collection.)

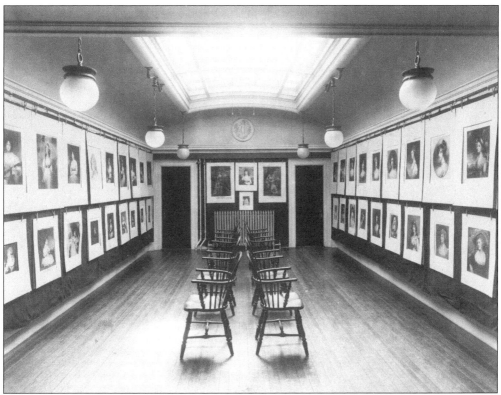

The cove-ceiling art gallery on the second floor of the library was mounted with an exhibit of lithographs of famous ladies of the early 19th century, as seen in this photograph from 1914. The door on the left leads to the former Trustees Room and that on the right to the Milton Room, where the photograph and book collection of the Milton Historical Society is kept. (Courtesy Milton Historical Society.)

Nathaniel Thayer Kidder (1860–1938) was the son of Henry Purkett Kidder, the co-founder with Oliver White Peabody of the investment house of Kidder, Peabody, & Company. An avid horticulturist, serving as the first tree warden in town, Nathaniel T. Kidder served as president of the Massachusetts Horticultural Society from 1893 to 1895. Kidder was once described as "a quiet man of gracious presence." He was president of the trustees of the Massachusetts General Hospital and was elected a trustee of the Milton Public Library in 1894, serving as treasurer from 1901 to 1907 and as chairman from 1907 to 1938. (Courtesy Milton Public Library.)

The Kidder Branch of the Milton Public Library was designed by Eliot T. Putnam, built on Blue Hill Parkway near Mattapan, and opened in 1929. A one-story Harvard brick building, it has a modillion cornice and a pedimented entrance supported by four Doric columns. The 12-over-12 windows and the fanlight over the entrance lend a distinctly Colonial Revival aspect to the library. (Courtesy Milton Public Library.)

Eliot T. Putnam (1880–1946) was the architect of both the Kidder Branch at Mattapan and the East Milton Branch of the Milton Public Library. A graduate of Harvard, Class of 1901, he attended the Ecole des Beaux Arts in Paris for two years of architectural study, after which he was a partner of Joseph Chandler in the firm of Putnam & Chandler. Putnam and his wife, Marguerite Sumner Putnam, initially lived at 126 Adams Street in Milton, but later moved to Blue Hill Avenue near the corner of Brush Hill Road in Milton. (Courtesy Milton Public Library.)

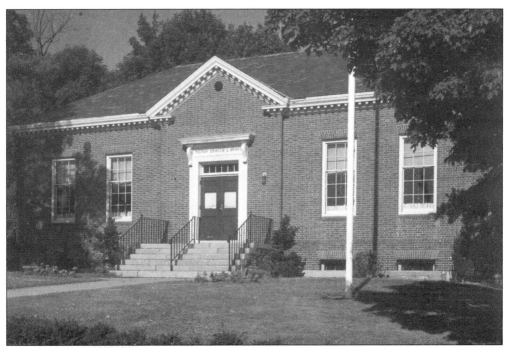

The East Milton Branch Library was also designed by Eliot T. Putnam. The library was built of Harvard brick by local contractor C.C. Fulton & Son. It has a graceful pedimented entrance with a slightly projecting center section and a slate roof. (Courtesy Milton Public Library.)

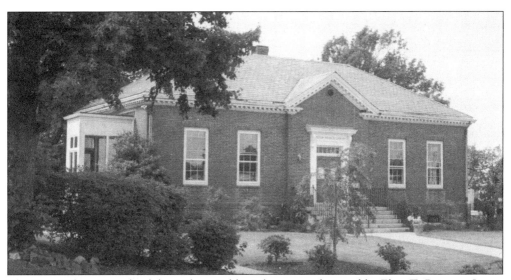

The East Milton Branch of the Milton Public Library was designed by Eliot T. Putnam. It was built on the land between Edge Hill Road and Hollis Street that was donated to the Town of Milton by Nathaniel T. Kidder. A simpler version in Harvard brick than the Kidder Library, it is distinguished by its heavily dentilled cornice and pediment. The grounds of the library were recently landscaped by Thayer Nursery in memory of Robert and Anna Oldfield, longtime supporters of the library. Robert Oldfield was the former owner of Thayer Nursery on Hillside Street in Scott's Woods.

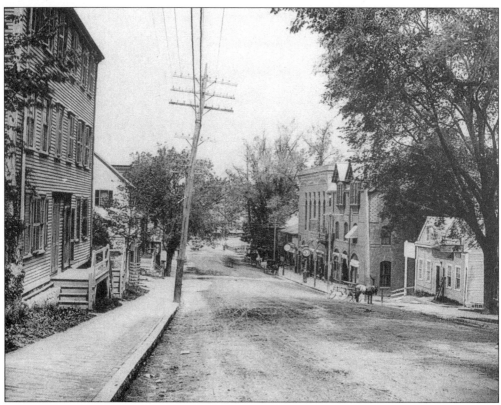

In a view looking down Adams Street toward Milton Village at the turn of the century, wood-framed buildings are dwarfed by the impressive Associates Hall on the right, which had stores along the street. On the far right was the Milton Public Library from 1882 until 1904; the first telephone exchange in Milton was in this building in 1881, being a connection to Nye's, later known as Puffer's Apothecary Shop.

Arthur Rotch (1850–1894), in association with George T. Tilden (1845–1919) as the architectural firm Rotch & Tilden, designed the Associates Hall at Milton Village. Rotch was a graduate of Harvard and the Massachusetts Institute of Technology (MIT), studying architecture with William Robert Ware of the firm Ware and Van Brundt. Tilden attended the Lowell Institute, the precursor to Ware's school at MIT, entering the firm of Ware and Van Brundt before co-founding Hartwell & Tilden and later Rotch and Tilden. Rotch was a benefactor of both the Boston Museum of Fine Arts and the Rotch Traveling Scholarship for architects and draftsmen. Tilden was the uncle of Joseph Tilden Greene (1862–1911), a noted architect who designed the Bispham Building in Dorchester Lower Mills and the Lithgow Building in Dorchester's Codman Square.

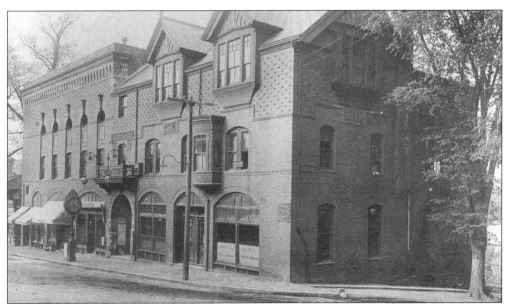

The Associates Hall is an impressive red brick and terra-cotta Queen Anne structure with Romanesque arches along the first floor and arched windows above. The patterned brick, terra-cotta tiles and decoration and a head of Athena Nike, favorite daughter of Zeus, creates a varied façade, and two massive dormers above an oriole window punctuate the slate roof. A superb design, it was adroitly said in 1892 that the "beauty of design and artistic finish characterize all the plans of Messrs. Rotch & Tilden, and their work stands among the best in the country." (Courtesy Milton Public Library.)

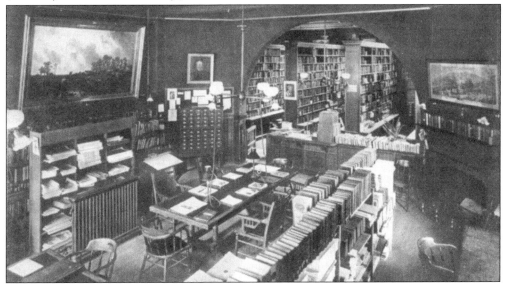

Between 1882 and 1904, the Milton Public Library rented a portion of the first floor of the Associates Hall for a reading room, repository, and circulating library. Books were shelved in every available corner of this reading room, which is dominated by a large landscape by Voltz (donated in 1882 by Henry P. Kidder) on the left and the Hinckley portrait of John Swift (donated in 1897 by Elizabeth Rogers Swift, his daughter) beside it. Both paintings are now in the Central Library on Canton Avenue. (Courtesy Milton Public Library.)

"Baron" Hugo Englebert Lira and his wife, Edith Esabella Hamilton Lira, are remembered today by the bandstand that he donated to Milton in memory of his wife in 1990. Baron Hugo (1904–1992) was one of the last big band leaders and was regarded as "the king of the Totem Pole Ballroom," a once popular Newton nightclub. Forming a 35-piece orchestra in 1936, Baron Hugo played at the big venues, including the Riverside in Neponset, Kimball's Starlight Ballroom, and Fieldstone-on-the-Atlantic. Lira also directed the Miltones, a group of male singers who performed by telling old stories through music and song. (Courtesy Milton Historical Society.)

The Lira Bandstand and the present Milton Town Hall create a more modern architectural interpretation to the venerable town common. The bandstand was built (after considerable debate at town meeting) in 1990 on the site of the old town hall. It was dedicated on Veterans Day 1990 with a performance by the Milton High School band. The present Milton Town Hall was designed by Richard C. Stauffer & Associates of Washington, D.C., and was built in 1970 by the Quincy contracting firm Dunphy & Craig, after which the old town hall was demolished.

Two

COLONIAL
ARCHITECTURE

Colonial architecture is considered the First Period of American architecture, or the period extending from 1630 to 1780. During this period, most houses built in Massachusetts Bay Colony drew their designs from traditional English framing, but used the vast amount of timber available in the New World. In the first decades of the settlement, housewrights built houses in either the East Anglian or West Country framing design. Interestingly, both the Capen House and the Tucker House represent East Anglian construction.

During the Colonial period, almost every house was a simple wood-framed house that was expanded over a period of time with gables, lean-tos, and dormers to create additional living space. These houses retained their post-Medieval aspects with wood clapboarding, banked window casements, and often overhanging second stories with pendill drops as decorative motifs. It was not until the 1740s that one could actually say an American influence had permeated these designs, as most were direct descendants of the earlier styles. With the embellishment of entrances with pediments, pilasters or columns, these Colonial houses often seemed barren in ornamentation when compared to English houses of the same period.

In Milton, most houses of the Colonial period were simple and straightforward. Those of the provincial government's aristocracy such as Gov. Jonathan Belcher, Gov. Thomas Hutchinson, and Provincial Treasurer William Foye had houses that were more fashionable, though a provincial interpretation of English prototypes.

> *The hale, old house! Long may it stand, beneath its spreading elms!*
> *And warm and cheer those yet to come, as those in far-off realms.*
> —Littlefield

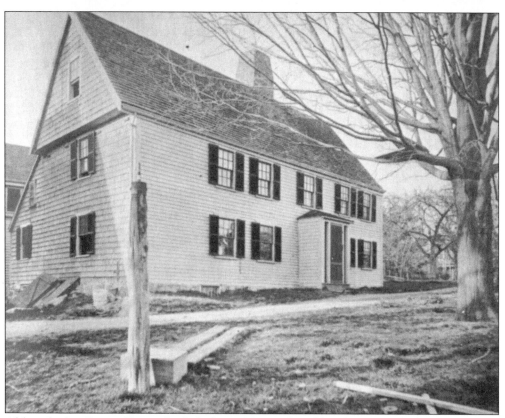

Although the Capen House, built before 1658, is the oldest house in Milton, it was not constructed in town. Kenneth G. T. Webster moved it from Dorchester to 427 Hillside Street in 1909 to save it from demolition. It is a mirror image of the Pierce House (*c.* 1650) in Dorchester; both were examples of East Anglian construction, exemplified by exposed sills and roof construction using principal and common rafters, which are thought to have been built by John Whipple, a local carpenter who left Dorchester in 1658. The house was purchased for $50 by Dr. Webster from W.H. Crosby, carpenter and builder, and each piece of the house was numbered before being dismantled and re-erected on Hillside Street in Milton. (Courtesy Dr. Ward I. Gregg and Roger L. Gregg.)

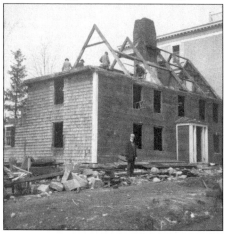

Kenneth Grant Tremayne Webster (1871–1942) saved the Capen House from demolition by having it moved in 1909 from the corner of Washington and Rosedale Streets in Dorchester to their property on Hillside Street in Milton. Dr. Webster stands in front of the house as it was being dismantled by workers of W.H. Crosby, with a three decker recently built on the next lot. A graduate of Dalhousie and Harvard, Webster was assistant professor of English at Harvard University and assistant dean of the Summer School of Arts and Sciences. A native of Nova Scotia, he also saved the oldest house in that province of Canada. (Courtesy Dr. Ward I. Gregg and Roger L. Gregg.)

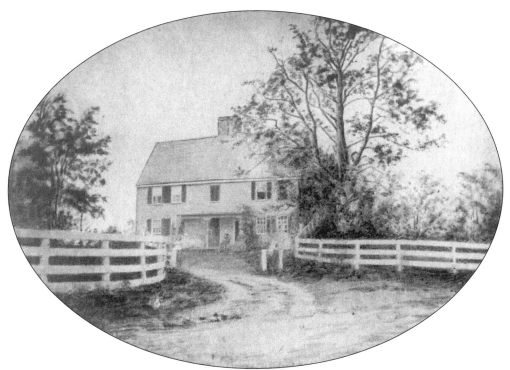

The Robert Tucker House was built in 1680 and is the oldest house built in Milton still surviving. Tucker emigrated to Massachusetts Bay Colony from Milton-near-Gravesend in Dorset, England, and initially settled in Weymouth. Tucker moved to Milton in 1662, the year it was incorporated as a town, and served as the first town recorder; it is thought that the name of Milton, Massachusetts was derived from his place of birth. The house was moved in 1895 to the Whitney Estate at 678 Brush Hill Road. (Courtesy Milton Public Library.)

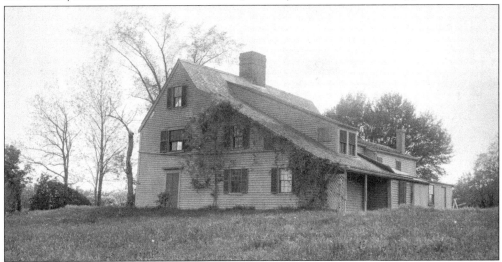

The rear lean-to of the Robert Tucker House—of East Anglian construction with a roof structure similar to that of the Capen House, though it is at least 15 years later—shows how the house was enlarged in the 18th century. A sweeping saltbox roofline was added to the rear of the house, creating additional living space in the rear. (Courtesy Milton Historical Society.)

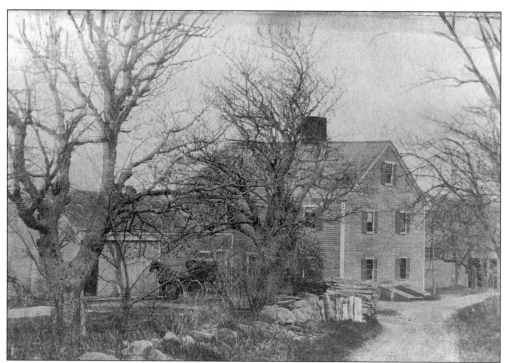

The Sumner House was built on Brush Hill Road in 1684. Roger Sumner (1632–1698) was the progenitor of the family, settling on Brush Hill in Milton in 1678. (Courtesy Milton Public Library.)

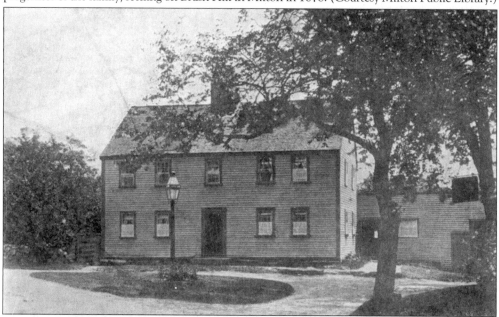

The Houghton House was built "at Scott's Woods nigh unto Brush Hill" in 1690 by Ralph Houghton, a native of Lancashire, England. A devout Puritan, Ralph Houghton (1623–1705) had fought under Cromwell against Charles I. He came to America in 1645. The 17th-century house stood for many years, sheltering seven generations of Houghtons near the Hoosic-Whisick, the pond now known as Houghton's Pond. (Courtesy Joseph LoPiccolo.)

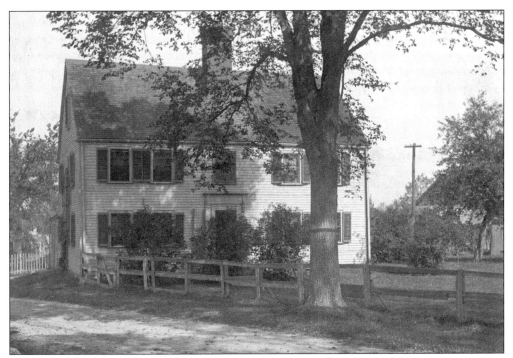

The Deacon Manassah Tucker House was built in 1707 at the corner of Canton Avenue and Robbins Street. A Colonial house with a saltbox addition to the rear, the simplicity of the overall design with a pediment over the entrance makes for a pleasant, though simple house. Manassah Tucker (1654–1743) was one of many Tucker family members who lived on or near Robbins Street. (Courtesy Milton Public Library.)

The Davenport House was built in 1707 at 1493 Brush Hill Road. Built by John Davenport (1664–1725) after moving from Dorchester, the early-18th-century wood-framed house with a lean-to was originally sited on a 35-acre tract that was used for farming. (Courtesy Milton Public Library.)

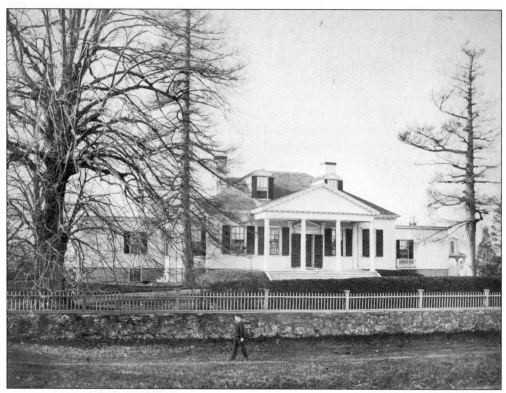

Unquety was the country seat of Royal Gov. Thomas Hutchinson, who had summered in Milton from 1743 to 1774 at what he said was "the place [he] loved the best." Leaving for England in 1774, the house was confiscated by the provincial government and was later sold to Barney Smith, who lived on the estate in great style. John Adams, later second president of the United States, said of Hutchinson, "He had been admired, revered, rewarded, and almost adored; and the idea was common that he was the greatest and best man in America." (Courtesy Milton Historical Society.)

Thomas Hutchinson (1711–1780) was the last royal governor of Massachusetts Bay, serving from 1770 to 1774. His able but often maligned public service included representative in the General Court of the Province of Massachusetts, speaker of the house, judge of probate, lieutenant governor, and chief justice. An adroit historian, he was the author of *The History of Massachusetts Bay*. His ancestors, William Hutchinson (1586–1642) and the fiercely independent Anne Hutchinson, had land in what is now East Milton, though they lived in Boston in the early years of Massachusetts Bay Colony.

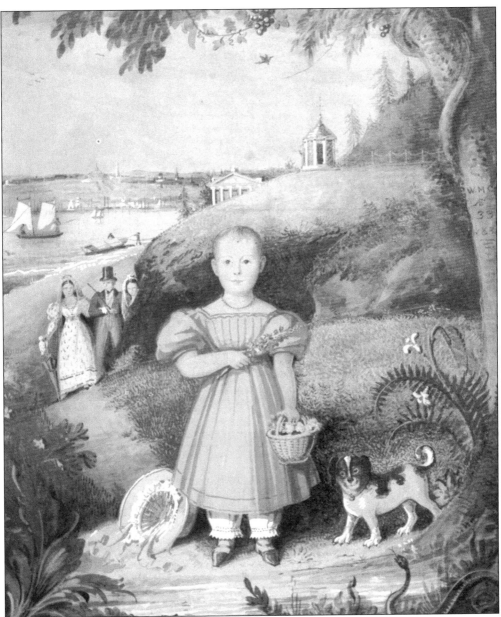

The Roxbury artist John Ritto Penniman painted Ann Elizabeth Crehore in 1836. Attired in a fashionable frock, the child holds a flower and a basket of flowers as her pet dog frolics in the foreground. Her parents (Diana and John Shepard Crehore) and a friend walk up the path on the left as a sloop passes by on the Neponset River. Ann Elizabeth was the daughter of Diana Ames Crehore, who hybridized the Diana grape, from a seed of the catawba grape, a bunch of which hangs from above on a vine intertwined on the tree. John S. Crehore was a chair maker with two shops—one at Lyman Davenport's place on Canton Avenue and the other on Milton Hill, now the site of the Capt. R.B. Forbes House. The columned building on the left center and the summerhouse surmounting Milton Hill (though inaccurately placed) are thought to depict the former Hutchinson House, which was occupied at this time by Barney Smith. (Formerly in the collection of Nina Fletcher Little.)

Jonathan Belcher (1682–1757) was royal governor of Massachusetts and New Hampshire, serving from 1730 to 1741; he afterwards served as governor of New Jersey from 1747 to 1757. Belcher's nephew was William Foye (1681–1759), who served as provincial treasurer of Massachusetts Bay Colony; Belcher purchased the Holman property in 1739 and kept it as a country seat in Milton.

Long has thy Nation loved thee; Sage in youth,
In manhood nobly bold and firm to Truth;
Shining in arts of Peace; yet midst a Storm
Skillful t'advise, and vigorous to perform

—I. Watts

The Madame Belcher House was built in 1776 on the foundations of the summerhouse of Governor Belcher. The house still stands at 26 Governor Belcher Lane off Adams Street. The Belcher House was purchased in 1940 by the Milton Historical Society as its headquarters and was later sold in the mid-1950s. (Courtesy Milton Public Library.)

Edward Hutchinson Robbins (1758–1829) was the son of Rev. Nathaniel Robbins, minister in Milton between 1751 and 1795. An attorney, he served as lieutenant governor of Massachusetts between 1802 and 1807, later serving as judge of probate for Norfolk County. He founded Milton Academy in 1798 and served as its first president for 32 years. He married Elizabeth Murray, and after 1805 they lived on the Murray Estate on Brush Hill.

James Smith (1688–1769), a wealthy sugar refiner, built the Smith-Murray-Robbins House in 1734, after which his widow, Elizabeth Murray Smith, bequeathed the estate to her nieces, Dorothy Murray Forbes and Elizabeth Murray Robbins. Edward and Elizabeth Murray Robbins moved from Milton Hill to this estate at Brush Hill in 1805.

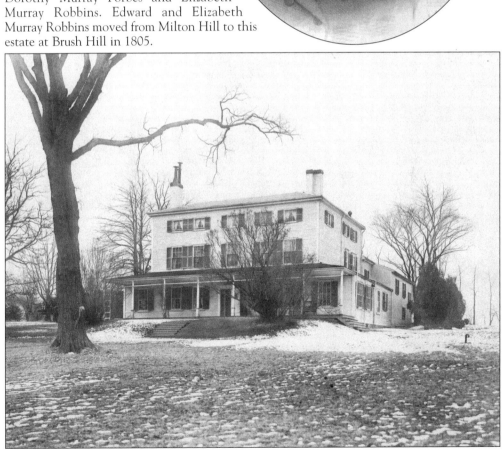

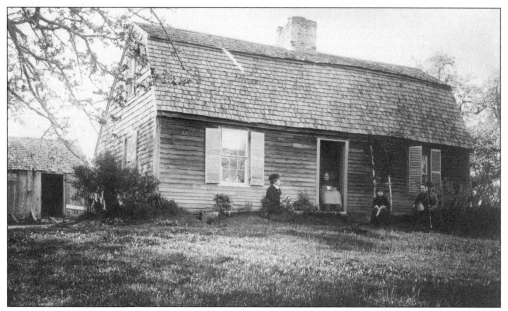

The Crossman House was built *c.* 1760 on Unquity Road in Scott's Woods. Here, members of the Crossman family pose in front of the house *c.* 1885. Mrs. Crossman, seated in the doorway, died that year. The house was set on 26 acres and was demolished in 1922. (Courtesy Milton Historical Society.)

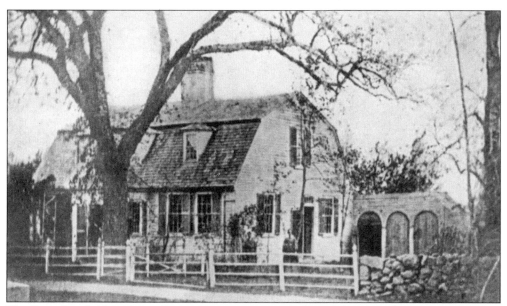

The Daniel and Alice Street Briggs House was a gambrel-roofed cottage built *c.* 1785 in East Milton. The house served as the East Milton Branch Library in 1893 after the reading room in East Milton was destroyed by fire.

The Gooch-Churchill House was built in 1740 on Adams Street just south of Churchill's Lane. Built by Col. Joseph Gooch (1700–1770), the Colonial house has an elegant pedimented entrance similar to that of the Suffolk Resolves House. (Courtesy Milton Historical Society.)

Asaph Churchill (1765–1841), who as been described as "one of the ablest lawyers in Norfolk County," moved to Milton in 1805, purchasing the house of Edward H. Robbins. A representative in the General Court, he was "a man of public spirit and enterprise, but of independent disposition and strong individuality." Churchill's Lane, which runs from Adams to Centre Streets, was named in his honor.

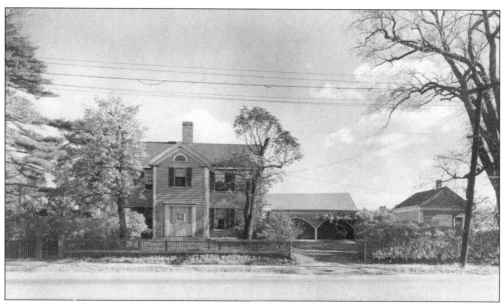

The Wells-Mather-Hinckley House was built in the mid-18th century at the corner of Brook and Ridge Roads, opposite the Town Field. A typical mid-18th-century house, it had a projecting pedimented center section. On the far right is Hinckley's studio, where he painted 478 combined landscape and animal pictures with the aid of sketches from nature. It has been said that Hinckley's "representations of wild and domesticated animals with their tranquil landscape settings are masterpieces of composition, brushwork, coloration, and texture." (Courtesy Milton Historical Society.)

Thomas Hewes Hinckley (1813–1896) was a noted painter who specialized in "farmscapes," or landscapes with animals. An accomplished, self-taught artist, he painted nature as he saw it and the "scenery of his native town has furnished him abundant material for his brush." (Courtesy Milton Historical Society.)

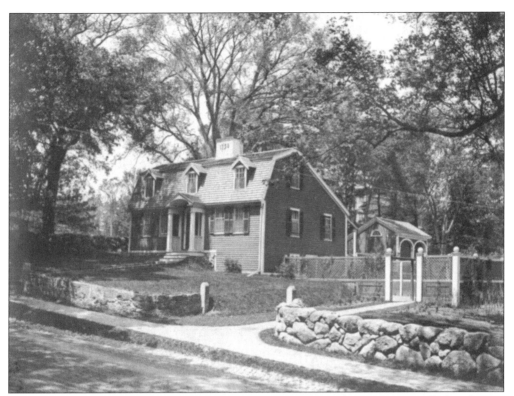

Nathan Babcock (1711–1777) built his house in 1753 at 362 Adams Street near Father Carney Road. A small gambrel-roofed Colonial with frontal dormers, it has the date of the house on the center chimney. (Courtesy Milton Public Library.)

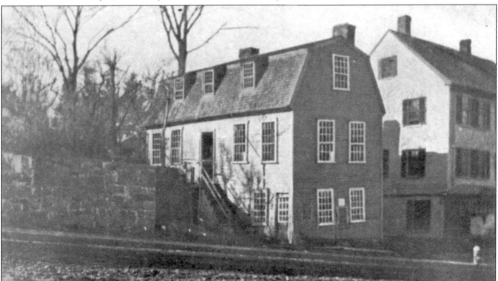

The Benjamin Crehore House and Shop was built *c.* 1760 on Adams Street between Eliot Street and Canton Avenue in Milton Village. In this shop, Benjamin Crehore (1765–1832), a skilled instrument maker and mechanical genius, made the first pianoforte and bas-viol in this country. (Courtesy Milton Historical Society.)

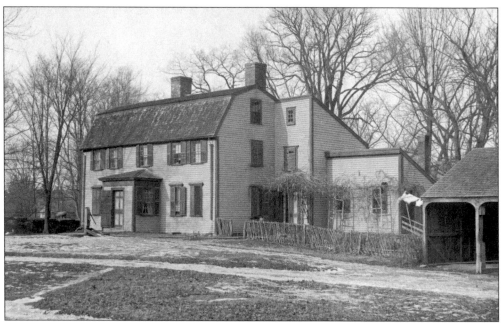

James Boies (1702–1798) built this house in 1765 near Unquetyquisset, or Mattapan. A native of Ireland, Boies established a paper mill in Milton in 1759. The house still stands at 30 Curtis Road off Blue Hill Avenue. (Courtesy Milton Public Library.)

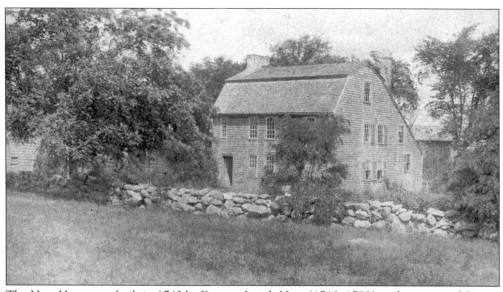

The How House was built in 1743 by Deacon Josiah How (1718–1792) at the corner of Centre Street and Randolph Avenue. How was the deacon of the Milton Meetinghouse and a town selectman. A cobbler by trade, he served in the General Court for Milton. (Courtesy Milton Historical Society.)

Gen. Joseph Vose (1739–1816) built this house in 1761 on Vose's Lane at the corner of Canton Avenue. A five-bay façade Colonial house with a central chimney, it is set back from the street with a long stone wall along Vose's Lane. An old fashioned perennial garden in front of the house completes this charming property, which still remains in the ownership of descendants of the builder. (Courtesy Milton Public Library.)

The hall of the General Vose House was photographed in the late 19th century with an impressive Roxbury case tallclock on the left and other family heirlooms in the next room. The interior of this Colonial house retains its cased summer beams, bolection molding, and heavily fielded paneling. The roof and pedimented dormers were rebuilt in the early 20th century, but the character of the house was only enhanced. (Courtesy Milton Public Library.)

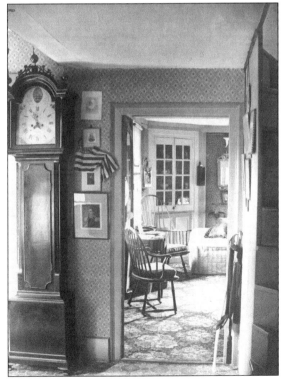

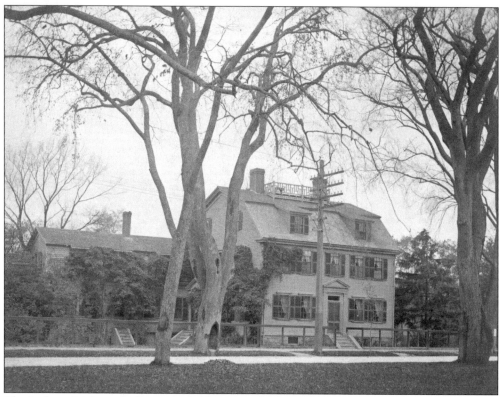

The Jackson-McLean-Hollingsworth House was built *c.* 1712 on the Blue Hills Parkway near Brush Hill Road at Mattapan. It was built by Jonathan Jackson. John McLean, benefactor of the Massachusetts General Hospital and for whom the McLean Asylum was named, lived here in his youth. In the mid-19th century, the famous artist George Hollingsworth (1814–1882) lived here; he was a son of Mark Hollingsworth (1777–1855), co-founder in 1809 with Edmund Pitt Tileston of the Tileston and Hollingsworth Paper Mill, successor to the firm of Boies & McLean. (Courtesy Milton Public Library.)

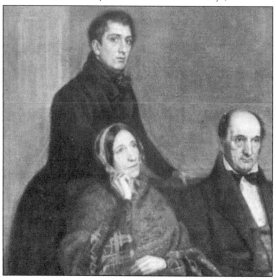

A detail of the painting *The Hollingsworth Family of Milton* shows the artist George Hollingsworth (1814–1882) standing behind his parents, Waitstill Tileston Hollingsworth and Mark Hollingsworth. George Hollingsworth was a teacher of the Lowell Institute Drawing School from 1859 to 1879, and his wife was Polly Eastman of Roxbury. (Collection of the Boston Museum of Fine Arts.)

Charles Howland Hammatt Billings (1818–1874) was a well-known architect who is best known for his National Monument to the Forefathers in Plymouth, Massachusetts, which was dedicated in 1859. The son of Ebenezer and Mary Davenport Billings, he was born in Milton in the family's home on Canton Avenue. A noted Boston architect, he was also a successful book illustrator and print maker.

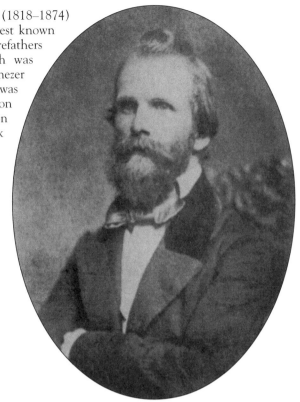

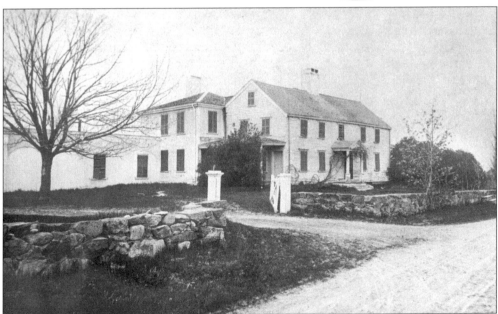

The Billings Tavern was built in 1681 on Canton Avenue and was often referred to as the "Blue Hill Tavern." Described in the 19th century as an "elegant tavern, boarding-house, and fruit gardens, kept by Ebenezer Billings, which is one of the most delightful summer retreats in this neighborhood." The tavern was demolished in 1885. (Courtesy Milton Public Library.)

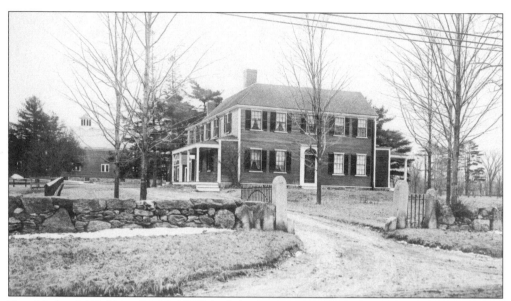

Rev. Nathaniel Robbins (1726–1795) built his house in 1755 on Canton Avenue just west of Robbins Street. Robbins was the minister of the Milton Meetinghouse from 1751 to 1795. A large Colonial house that had Federal porches added on the sides around 1800, it was to survive until 1971, when it was demolished and modern houses were built on its site. The granite gateposts still survive, along with the stone wall along Canton Avenue, though modern ranch houses have been built on its site. (Courtesy Milton Historical Society.)

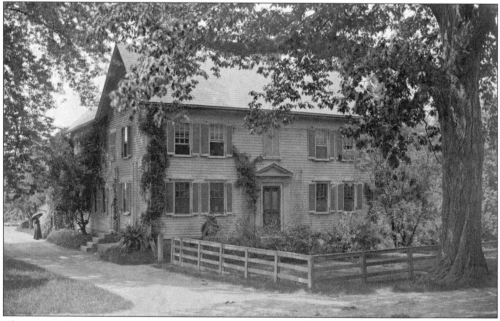

The Capen-Davenport-Sutermeister House was built in 1781 on Canton Avenue. A late-18th-century house, it was set on a large tract of land that was farmed as a commercial vegetable garden and plant nursery by Emmanuel Stermeister. His daughter was Margaret "Daisy" Sutermeister (1875–1950), a noted photographer in the late 19th century. (Courtesy Milton Public Library.)

40

Three

THE SUFFOLK RESOLVES HOUSE

In 2000, the Suffolk Resolves House celebrated the 50th anniversary of its move from Milton Village to 1370 Canton Avenue, a corner of the former Ayer Estate. Slated for demolition, the house was moved by William Morris Hunt, who was commissioned by Hannah Palfrey and James Bourne Ayer. It was transported in three sections from Adams Street in the village (the present site of Citizens Bank) up Eliot Street to Central Avenue, Brook Road, and thence along Truman Highway. From there, it went along Milton Street and east on Canton Avenue, where it was hoisted to the top of a terraced setting overlooking the avenue. Over the next few years, Mrs. Ayer and Mr. Hunt restored the house. They decorated it with period antiques and laid out the property with a privet garden and a sunken garden with a circular fountain. Upon their deaths in 1963, the Ayers bequeathed the house and its contents to the Milton Historical Society.

But why bother to preserve another mid-18th-century house? In essence, the Suffolk Resolves House, joined in 1785 from two separate houses, was the home and tavern of Daniel and Rachel Smith Vose. The house originally stood on Adams Street at Wharf Street and was visited by residents and travelers. In 1774, Daniel Vose hosted delegates of every town and district in the County of Suffolk, with Dr. Joseph Warren acting as chairman. These patriots signed the Suffolk Resolves—13 points of firm resolve that they felt had to be addressed by the king and his ministers. The Suffolk Resolves were more explicit and spirited than any other grievances drafted. They "discovered a sensibility more alive to the distress of the people, and more indignant at the conduct of administration, than appeared in the proceedings of the other counties." These resolves, signed on September 9, 1774, were couriered from Milton by Paul Revere to the Continental Congress in Philadelphia, where they were approved and accepted on September 17, 1774. In pointed instances, certain lines from the Suffolk Resolves were drawn for inclusion in the Declaration of Independence. It was nobly said, "The Resolves to which the immortal patriot here first gave utterance, and the heroic deeds of that eventful day on which he fell, led the way to American Independence. Posterity will acknowledge that virtue which preserved them free and happy."

Why were they called the *Suffolk* Resolves? Milton was a part of Suffolk County until 1793, when it became part of Norfolk County. This historic house remains an important part of the American Revolution. As the blue and white canvas banners in East Milton so appropriately say, it is "the birthplace of the American Revolution." The Revolution's goals were outlined, strengthened, and solidified in the house of Daniel Vose.

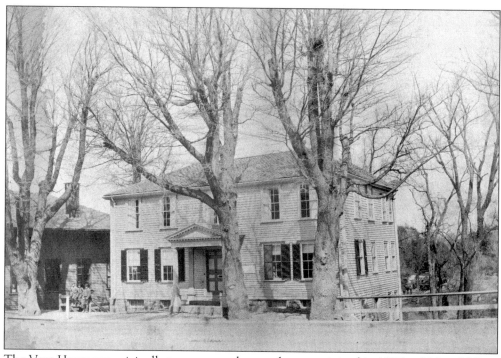

The Vose House was originally two separate houses that were joined in 1785 at Milton Village as the home of Daniel and Rachel Smith Vose. Shown in this c. 1870 photograph, the house was built directly on the Adams Street sidewalk, as it was a townhouse, versus its present siting on a terraced lawn. Known as the "birthplace of American Liberty," it was here on September 9, 1774, that the Suffolk Resolves were adopted by the delegates and couriered by Paul Revere to Philadelphia, where they were immediately "approved by the members of the Continental Congress, at Carpenter's Hall, Philadelphia" on September 17, 1774. The elms were planted by Dr. Amos Holbrook in 1785. (Courtesy Milton Historical Society.)

Daniel Vose (1741–1807) was, with his cousin and partner Joseph Fenno, a prosperous wholesaler and leading merchant of West Indian goods and manufactured goods. He lived in Milton Village. Vose later operated an extensive grocery and shipping business in Milton, in addition to a fleet of sloops, a paper mill, chocolate mill, sawmill, gristmill, lumber wharf, and distillery. His wife was Rachel Smith Vose, daughter of Jeremiah Smith (1704–1790), the owner of the paper mill at Milton Village, which was later inherited by Vose. (Courtesy Milton Historical Society.)

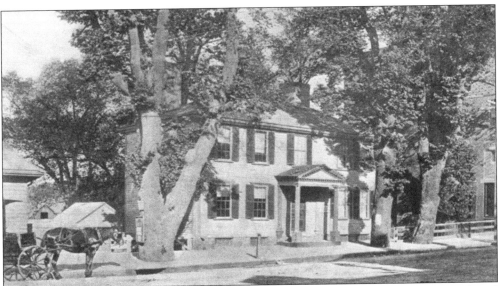

The Daniel Vose House, popularly called the Suffolk Resolves House, is a five-bay Colonial house with a hip roof that was two separate houses moved and joined in 1785. The entrance portico has a heavily dentilled pediment supported by Doric columns, which rest on plinth bases. Dr. Amos Holbrook and his wife, Patience Vose Holbrook (1774–1789), lived here until 1801, after which it was occupied by Thaddeus W. Harris (1795–1856). Harris was an eminent entomologist and later a librarian at Harvard who had married Catherine Holbrook, the doctor's daughter. Harris's best-known book was *Treatise on Insects Injurious to Vegetation*, which though dry reading was an important book. (Courtesy Milton Historical Society.)

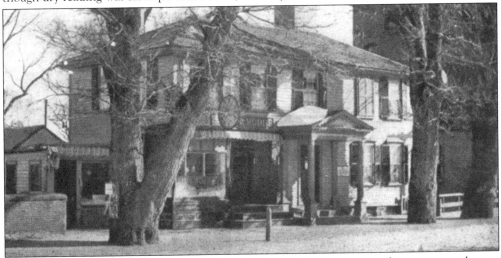

By the early 20th century, the Suffolk Resolves House had been converted to commercial space on the first floor, with an apartment above. Owned successively by Nathaniel Morton Safford and Alexander H. Copley, it was commercial income property. In 1929, the house was occupied by the L.R. Gibson & Son Plumbing Shop and Charles W. Stiles' Electrical Shop, which occupied the front rooms. Following this, a book drop for the Milton Public Library was located here. Standing like tall sentinels on either side of the house were majestic elms that were cultivated on the Brush Hill Estate of James Murray and set out on Adams Street in 1785. (Courtesy Milton Historical Society.)

Lauriston Livingston Scaife (1850–1926) in his 1921 book *Milton and the Suffolk Resolves* described in fascinating detail the events and times leading up to the signing of the Suffolk Resolves on September 9, 1774, at the Daniel Vose Tavern in Milton Village. Scaife's book extolled the Suffolk Resolves as "words of decency, firmness, and wisdom." It not only chronicled the history that occurred here in 1774, but also raised the public's awareness of how this historic house was being treated so ignobly, eventually leading to its preservation. A white marble tablet had been placed on the house on the centennial of the signing of the Suffolk Resolves. (Courtesy Milton Public Library.)

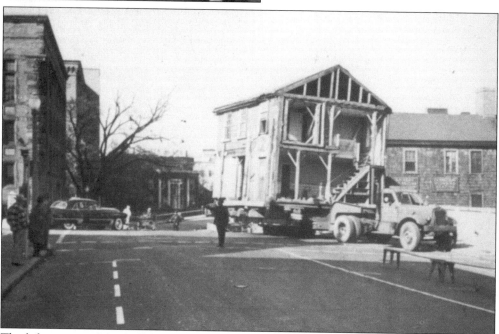

The left portion of the Suffolk Resolves House was separated from the whole and moved on a flatbed trailer from Milton Village to 1370 Canton Avenue on October 17–18, 1950. Here the flatbed stops at the junction of Adams and Eliot Streets. On the left is the administration building of Baker's Chocolate (designed by Milton architect George F. Shepard Jr. and built in 1919). On the right is the Martin Building with the electrician's shop of F.J. King & Son. The house would eventually stop at Central Avenue and Hinckley Road overnight before proceeding to its final destination. (Courtesy Milton Historical Society.)

William Morris Hunt was the restoration architect-engineer of the Suffolk Resolves House in 1950. A great friend of Hannah and James Ayer, he undertook the two-day moving of the house from Milton Village to a corner of the Ayer Estate on upper Canton Avenue. Hunt is, in his own words, best known for his theatre history involvement, especially the Theatre Arts Collection at Harvard, as well as his dissemination of theatre history throughout the greater Boston area. (Courtesy Milton Historical Society.)

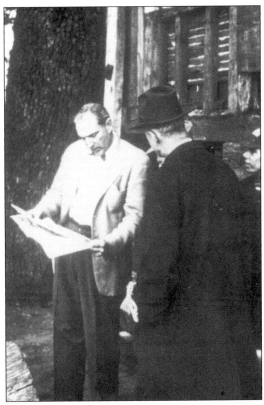

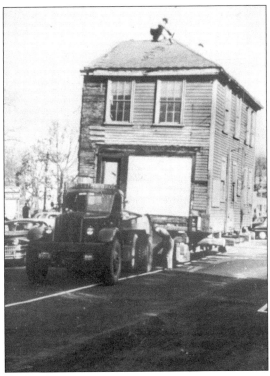

The right portion of the Suffolk Resolves House was moved on a second flatbed truck. The route from Milton Village was Eliot Street to Central Avenue, Brook Road, Truman Highway, Milton Street, and east on Canton Avenue to the Ayer Estate. This portion, representing the present dining room, kitchen, canopy bedroom, and study, has a worker securing binders on the roof as it stops on Adams Street before turning onto Eliot Street. Notice the former storefront window that has been covered with sheets of wood before it was restored to its 18th-century façade. (Courtesy Milton Historical Society.)

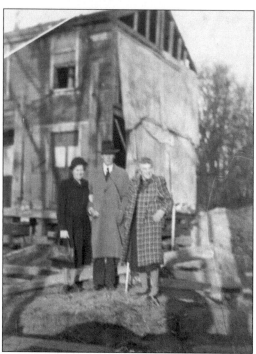

Hannah Palfrey Ayer (1888–1963), right, poses in 1950 with Rosamond Pier Hunt and restoration architect-engineer William Morris Hunt in front of a portion of the Suffolk Resolves House on the edge of her estate on Canton Avenue. Without the generous offer of the Ayers to move and restore the Suffolk Resolves House, it would have been demolished, as it was in precarious shape. (Courtesy Milton Historical Society.)

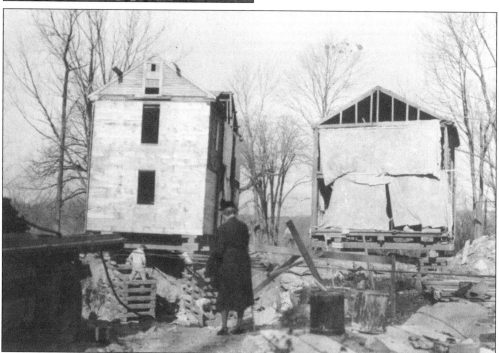

Mrs. Ayer stands on the building site looking at the two portions of the Suffolk Resolves House as they are maneuvered into position before being set on the concrete foundation; the notation by one of her daughters on the back of the photograph wryly says, "Mother surveying her ruins." The portion on the left is the kitchen and study, while the attic window remains intact. (Courtesy Milton Historical Society.)

Harley Parker and his daughter, Penny Parker, peer from the frame of a window opening in the kitchen in 1950. The clapboards had been stripped from the rear, and the windows were removed. The horizontal planks would shortly be clapboarded again. (Courtesy Milton Historical Society.)

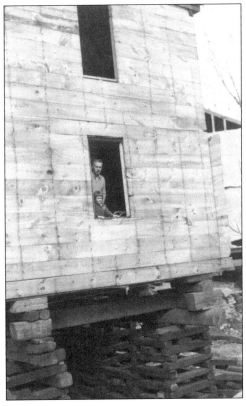

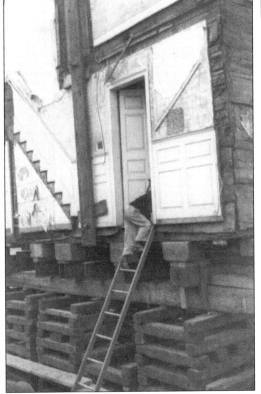

Jay Parker climbs a ladder and peers into the doorway to the dining room. The fine Colonial paneling and door, as well as the shadow of the stair stringers, are testimony to the generosity of Hannah and James Bourne Ayer in moving, restoring, and preserving the Suffolk Resolves House. Notice the pilings that supported the frame of the house until it was set on the concrete foundation. (Courtesy Milton Historical Society.)

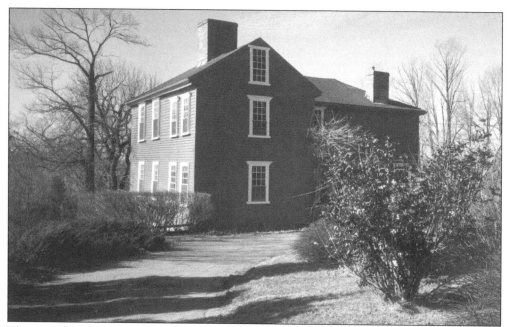

The rear of the Suffolk Resolves House was photographed in the early 1950s after the house was restored by William Morris Hunt. The difference in window sizes is evident on the second floor of the west side with 12-over-12 windows on the upper left and 9-over-9 on the upper right. Upon their deaths in 1963, Dr. and Mrs. James Bourne Ayer donated the Suffolk Resolves House and its contents to the Milton Historical Society. The society then moved its collection to the house, and it was opened to the public every Suffolk Resolves Day. (Courtesy Milton Historical Society.)

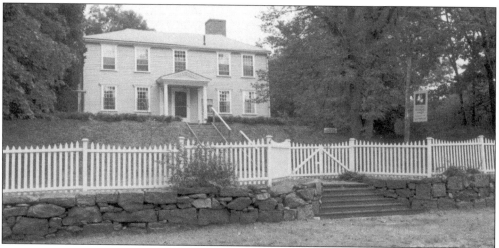

The façade of the Suffolk Resolves House today appears as it did in the mid-19th century, when it was in Milton Village. Set high on a terraced lawn overlooking Canton Avenue, the historic house has 12-over-12 reproduction windows to re-create its original design from 1785. As the headquarters of the Milton Historical Society, it is currently undergoing a second restoration by the noted Boston architect Roger Taylor Panek: a new wood shingle roof, a paint analysis for its original paint colors, and extensive carpentry work—all funded through the generosity of the Copeland Foundation.

Four

FEDERAL ARCHITECTURE

American Federal architecture began with Charles Bulfinch (1763–1844), who introduced the neoclassical style to Boston in the 1790s. Following a grand tour of Europe, where he saw the "wonders of Architecture and the kindred arts of painting and sculpture," Bulfinch returned to Boston and commenced to design (with no practical experience or professional training) cultivated and well-proportioned examples of the neoclassical style so popular in Europe as interpreted by the Adam Brothers. His creation of the Tontine Crescent, a connected series of row houses punctuated by a center pedimented pavilion on Franklin Street in Boston, was the first example of row houses in America. Built of brick painted gray to emulate the more expensive stone used in the Bath Crescent, Bulfinch's interpretation of fashionable architecture, American Federal architecture, became widely copied and has long been associated with symmetry, balance, and reason.

Although neither Bulfinch nor his successors, Asher Benjamin (1773–1845) or Peter Banner (an Englishman), designed houses in Milton, his style was adapted for Federal houses in the country town between 1795 and 1820. In many ways, the houses built during this period were similar to those built in Boston, except they were built of wood, whereas most in town were of red brick, often painted to resemble stone. In Milton, Federal houses were simpler in style and of a spare Federalist beauty. Construction and design was simpler, as the town was relatively rural throughout the 19th century. One house, however, is representative of high style Federal design—the Isaac and Mary May Davenport House on Brush Hill Road. Still owned by descendants of the family, this exquisite example of a square five-bay façade house has retained most of its embellishments, including roof balustrades, bold corner quoining, side porches, and pedimented entrances. Although the neoclassical period was more sophisticated in Boston, it was more direct in Milton, and was a shared sense of sizing and detail that can be identified with surviving houses of the period.

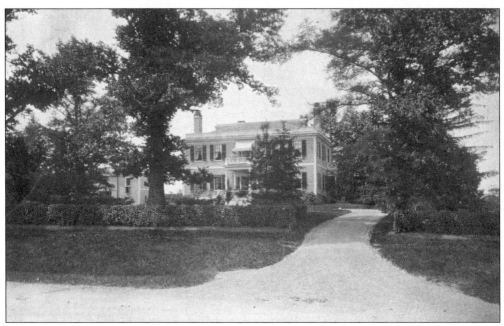

The Holbrook House, built in 1801 at the crest of Milton Hill, was once described as having been "built with a view to tasteful architecture." Built by Dr. Amos Holbrook, who lived here until 1842, it was later occupied by Francis (1804–1867) and Mary Abbot Forbes Cunningham (1814–1904). The Federal house overlooks Hutchinson Field and Boston Harbor beyond. Mrs. Cunningham, a sister of Robert Bennet Forbes and J. Murray Forbes, left her fortune to three trustees for the benefit of Milton residents. Cunningham Park on Edge Hill Road was named in her memory and perpetuates her generosity. (Courtesy Milton Historical Society.)

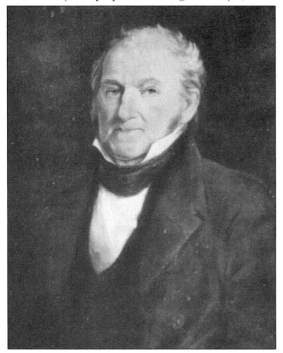

Dr. Amos Holbrook (1754–1842) was the local doctor, having established his practice in Milton in 1778. In 1809, he and John Mark Gourgas administered the first inoculation for smallpox in this country. Holbrook married three times: first to Melatiah Howard; second to Patience Vose, daughter of Daniel Vose; and third to Jerusha Robinson. He lived in the Vose House (the Suffolk Resolves House) until 1801, when he built the house now standing at 203 Adams Street on Milton Hill. Holbrook served as president of Milton Academy from 1830 to 1842. It has been said that his name was "connected with almost every enterprise looking to the prosperity of the town and the welfare of his fellow citizens."

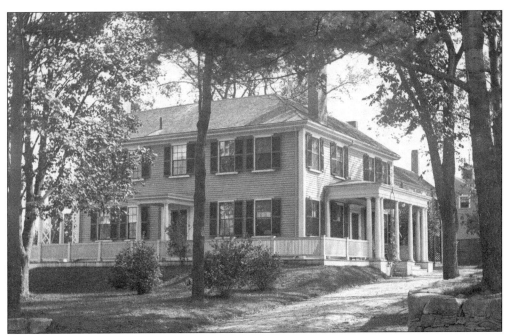

Dr. Benjamin Turner (1771–1831) built his house in 1795 on Canton Avenue at Atherton Street. Serving as town doctor after the removal of Dr. John Sprague to Boston, Dr. Turner married Avis Davenport in 1794. The side portico of the house has Doric columns, which were added in the Colonial Revival period, as was the porch railing along the front and side. (Courtesy Milton Public Library.)

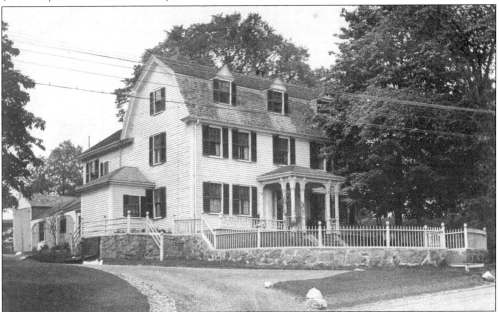

Deacon Nathan and Lucy Jacobs Tucker built their house in 1799 at 703 Brush Hill Road. A five-bay Federal house with gambrel-roof ends, it sits high above the road with a stone wall surmounted by an acorn post fence. The Italianate entry porch has been replaced by a Colonial Revival one with Doric columns supporting a pediment. (Courtesy Milton Public Library.)

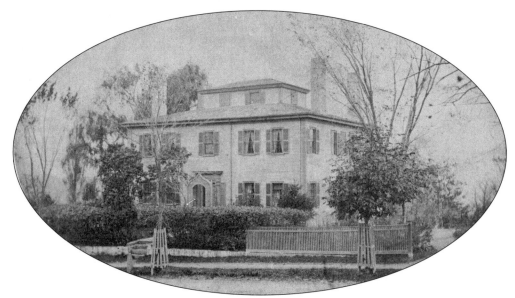

The Old Glover Tavern was built in 1799 on Adams Street, just south of Milton Village. Built by Dr. Samuel Kingsley Glover (1753–1839), first postmaster of Milton and town selectman, the entrance is framed by a lancet-shaped trellis. The house, which was remodeled in 1865, had superb views of Dorchester Bay and Boston Harbor, as well as the marshes at the foot of the hill, from the lantern windows in the attic. (Courtesy Milton Public Library.)

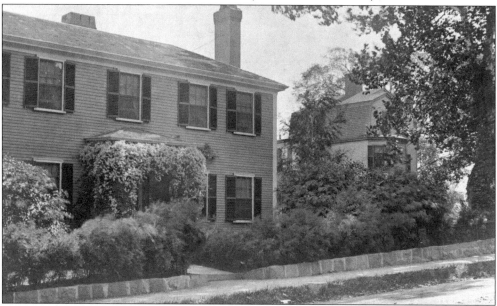

The Moses Whitney House was built in 1819 at 126 Adams Street just south of Milton Village. Gen. Moses Whitney (1775–1859) served as brigadier general of First Brigade, First Division, Massachusetts Militia. The symmetrical five-bay façade house still stands opposite the junction of Adams Street, Randolph Avenue, and Canton Avenue. Moses Whitney served as postmaster of Milton and later served as colonel of the local militia. The house on the right is the Adeline Dutton Train Whitney House at 134 Adams Street; Theodore Whitney built the house as a dower house for his mother about 1894. (Courtesy Milton Public Library.)

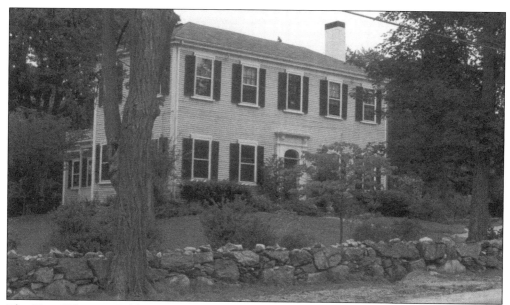

The Vose-Whitney-Field House is at 378 Canton Avenue. Built in 1795 by Isaac Davenport Vose, the Federal house with a five-bay façade originally stood at the head of Vose's Lane and was moved to its present site in 1860. The house was later owned by Seth Dunbar and Adeline Train Whitney, who called the estate Elm Corner. Mrs. Whitney was a poet and a popular writer of novels, among them her first literary work *Mother Goose for Grown Folks* in 1859 and later *Homespun Yarns, The New England Stories,* and her last book *Biddy's Episode.*

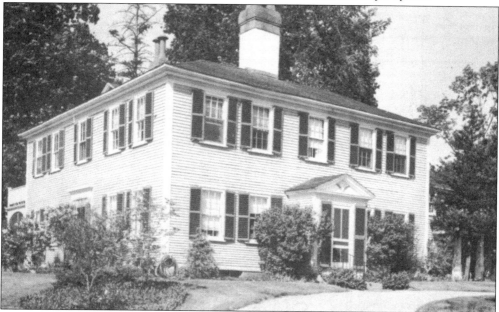

The Davenport-White House was built by Phineas Davenport *c.* 1810 at 1580 Canton Avenue. A five-bay square Federal house, it was one of numerous houses built on Upper Canton Avenue by the Davenports. Balstar Brook flows behind the house, crossing the avenue and eventually joining Pine Tree Brook. Just west of the house has been laid out Blueberry Lane, which has been developed with new houses in the last decade.

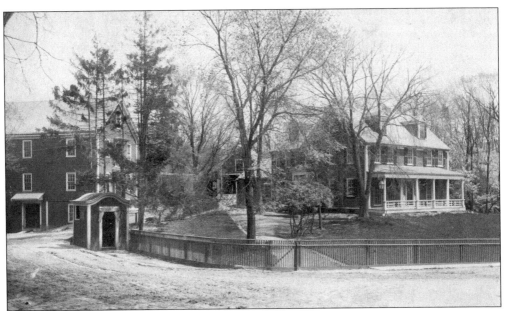

The Sanderson-Ware-Gallagher House was built in 1820 on Adams Street in Milton Village. On the left is the old paper mill built *c.* 1728 for Jeremiah Smith, later used by Dr. Ware for the production of chocolate. Isaac Sanderson, a papermaker in Milton Village, sold the house to Dr. Jonathan Ware, the producer of Ware's Chocolate. Later the home of Hugh Clifford Gallagher (1855–1931), president of the Baker Chocolate Company, it was demolished in 1901. (Courtesy Milton Historical Society.)

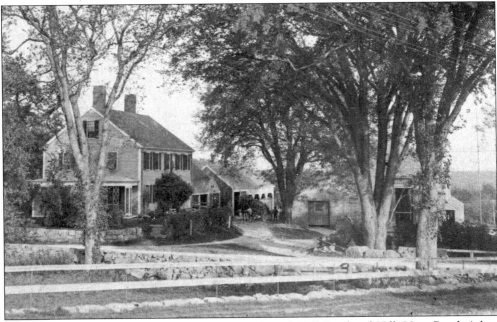

Jesse Vose built this house in 1829 at the corner of Brush Hill Road and Hills View Road. A late example of a Federal house, it followed the same designs as an earlier house but was deeper, creating a wider end gable. Set back from the road, which is bordered by a low stone wall, the views of Milton Center are as stupendous today as a century ago. (Courtesy Milton Public Library.)

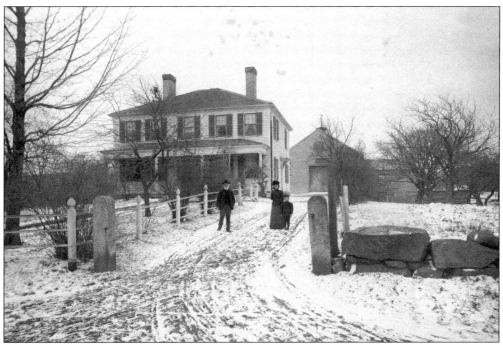

The Bezer Thayer House was built in 1802 on Hillside Street in Scott's Woods. Members of the Thayer family pose *c.* 1900 on the driveway to the carriage house, which has been crisscrossed by carriage wheels after a dusting of snow. (Courtesy Milton Historical Society.)

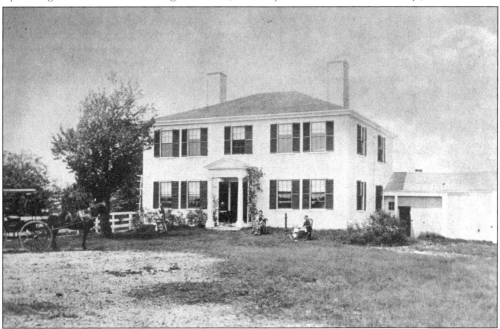

The James Tucker House was built in 1804 at 1100 Randolph Avenue opposite Hillside Street. A quintessential Federal house, its perfect symmetry with a hip roof, twin chimneys, and pedimented entrance porch supported by Doric columns extols the virtues of neoclassical architecture. (Courtesy Milton Public Library.)

The Isaac Davenport House was built in 1794 at 1465 Brush Hill Road. An impressive square Federal house with corner quoining and a hip roof encircled by a balustrade, the house was built by Isaac and Mary May Davenport on land purchased in 1706 by John Davenport, the ancestor of the family in Milton. Isaac Davenport (1753–1828) was in business with Samuel May (his father-in-law) and John McLean, who inherited the paper mill in Milton from his father. (Courtesy Milton Public Library.)

Samuel Tucker built Clark's Tavern in 1809 for his son, Joshua Tucker, on the Taunton Turnpike (as Randolph Avenue was once known) south of Hillside Street. Built as a five-bay Federal with a hipped roof and a porch with slender Doric columns, it is on a slight rise just south of Hillside Street. The front drive was bordered by a stone wall and wood barrier. It was kept as a hotel by Minot Thayer and by William H. Clark until 1888. At the turn of the century, F.A. Richards operated a grocery store here. Today, the former tavern is the headquarters of Copeland Properties. (Courtesy Milton Public Library.)

Five

THE GREEK REVIVAL AND THE GRANITE INDUSTRY

The Greek Revival was a re-creation of ancient Greece in its frozen ceremonial of order and serenity, a virtual embodiment of a new optimism, self-assurance, and affluence of the American Republic. Roger Kennedy says in his book *Greek Revival America* that it was "a state of mind and a style of life, and one that was most publicly expressed through architecture." The style became popular after the Greek independence from Turkey in the 1820s.

The Greek Revival flourished in the United States between 1820 and 1850. However, most local interpretations were vernacular forms built in wood. Two important examples of this style were built in Milton that created a vivid impression of how architecture could make an impact on society. The McLean-Boies-Austin House was built near Mattapan as a virtual temple with four monumental Ionic columns supporting a pediment. This house, built c. 1830, was probably the first example of this new style to be built in town and was unfortunately demolished in 1922. One house remains—what is today referred to as the Capt. Robert Bennet Forbes House, designed by Isaiah Rogers and built in 1833 on Milton Hill. Like the earlier example, it too was built of wood, but with boards laid flat on the façade, creating a smooth surface that was painted and sanded to imitate granite. The wide pilaster-girded façade and Ionic-columned entrance were impressive details. Like the McLean-Boies-Austin House, the Forbes House commanded its site.

Known for its purity of color, Greek Revival houses were usually painted stark white to imitate the white marble temples of ancient Greek ruins. The use of a portico front (often featuring pediments and columns, or pilasters) created façades that restored balance and provided stability in architecture. The Greek Revival, according to architectural historian Talbot Hamlin, was the "perfect expression" of a culture that was "radical, libertarian, experimental, eagerly searching for American expression. A country rich, expanding, not yet densely populated; a country with its agriculture and its growing industry still in fundamental balance."

Eventually, the Greek Revival became the perfect style for granite, which was quarried in Quincy, Massachusetts, by Gridley Bryant. With the use of hewn granite, the Greek Revival took on a powerful, permanent aspect of preserving the legacy of the American Republic. The Granite Railway brought granite to Boston for use in the construction of the Bunker Hill Monument, St. Paul's Church, Quincy Market, and the Boston Custom House.

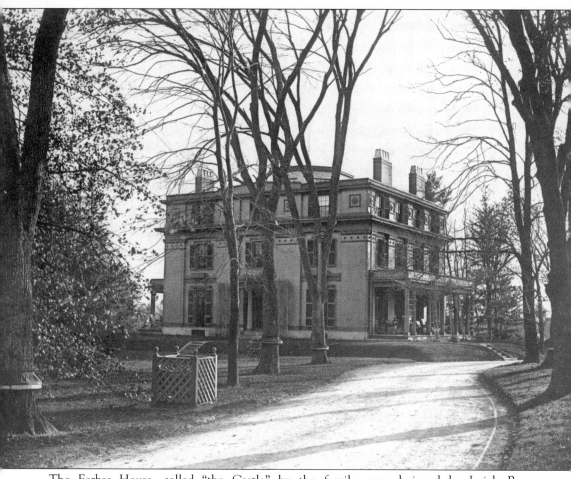

The Forbes House, called "the Castle" by the family, was designed by Isaiah Rogers (1800–1869). It was built in 1833 at the crest of Milton Hill as a summerhouse for Margaret Perkins Forbes (1773–1856), the widow of Ralph Bennet Forbes and sister of merchant prince Thomas Handasyd Perkins. The house was originally two stories with an octagonal roof lantern. In 1873, according to J. Murray Forbes, the "roof was raised and the L was added" by Peabody and Stearns, a noted Boston architectural firm of partners Robert Swain Peabody (1845–1917) and John Goddard Stearns (1843–1917). After Mrs. Forbes's death, the house was owned by J. Murray Forbes (1845–1937) and Alice Bowditch Forbes (1848–1929). It was later owned by their eldest daughter, Mary Bowditch Forbes (1878–1962).

J. Murray Forbes was the president of the Forbes Syndicate that owned the Walter Baker Chocolate Company in Dorchester Lower Mills from 1897 to 1928, after which it was sold to the Postum Corporation (later known as General Foods). Mary Bowditch Forbes, who lived here until her death (the family townhouse at 107 Commonwealth Avenue had been sold after 1937), was a major collector of Lincolniana. She had local carpenter Thomas Murdock build on the estate an exact replica of the log cabin birthplace of Abraham Lincoln, which she furnished with Lincoln memorabilia and opened to the public every February 12 in honor of Lincoln's Birthday. Today, the house is known as the Capt. Robert Bennet Forbes House and is open to the public for guided tours. The house is furnished with Forbes family possessions and China Trade objects that chronicle their involvement with the Far East, showing how a wealthy Milton family lived in the mid-to-late 19th century. (Courtesy Milton Public Library.)

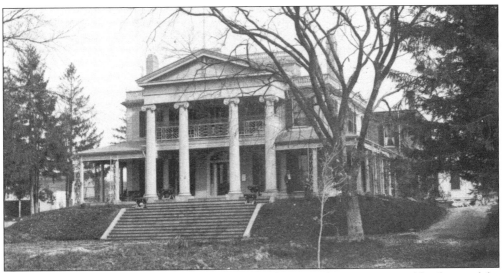

The Boies-Austin House was an impressive Greek Revival mansion, possibly designed by Russell Warren, on Mattapan Street (now Blue Hills Parkway) between Eliot Street and Brook Road. It was built c. 1830 by Jeremiah Smith Boies (1762–1826), owner of the Boies & McLean Paper Mill in Milton and partner of John McLean, benefactor of the McLean Asylum in Charlestown (now in Belmont). It was later occupied by William Austin. The grand Ionic-columned mansion was set on a 6-acre estate between Eliot Street and Brook Road. Willoughby Road is the former carriage drive to the estate. (Courtesy Milton Historical Society.)

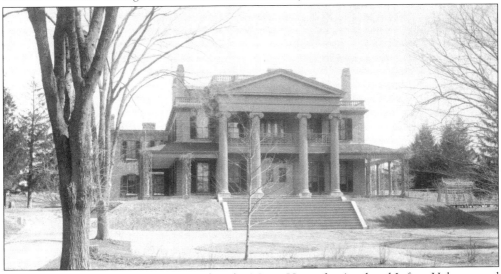

The Boies-Austin House was once used as the Morse Home for Aged and Infirm Hebrews and Orphanage, which was endowed by Leopold A. Morse, a member of the U.S. House of Representatives and a wealthy store magnate in Boston. Opened in 1889, the Morse Home had 32 rooms and a 60-bed capacity for elderly and orphan Hebrews. The credo of the home was, "Make each person young and old feel that they are our guests and are to be treated accordingly." The home was fully occupied until it was closed in 1914, when a larger facility was built in Dorchester. The former mansion was demolished in 1922, and two of the Ionic columns were reused on the façade of a two-family house built in 1922 at 542 Eliot Street. (Courtesy Milton Historical Society.)

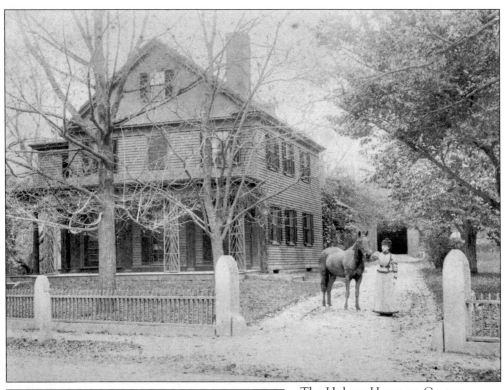

The Holmes House on Canton Avenue, a Greek Revival house built by Francis H. Campbell, had a colonnade of Doric columns supporting an entablature along the façade with trellises mounted on them. Elizabeth Rich Holmes (1876–1954) stands with her horse on the drive to the carriage house, which is flanked by lancet-shaped granite piers that still remain between 50 and 56 Canton Avenue. (Courtesy Milton Historical Society.)

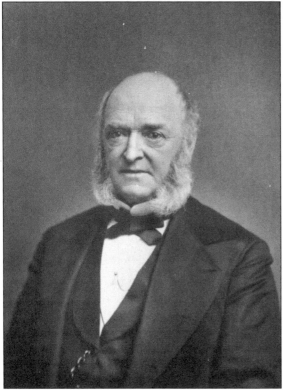

Christopher Columbus Holmes (1817–1882) was a leading physician in Milton in the mid-19th century. Holmes served as commandant of the Independent Corps of Cadets (ICC) between 1858 and 1868. The ICC armory was at Park Square in Boston. A noted musician who was devoted to sacred music, Holmes was a member of the Harvard Musical Association.

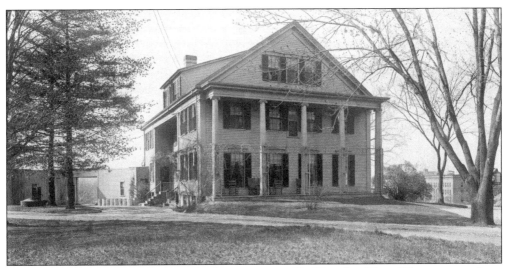

The Milton Hill House, a popular inn and resort operated by Theodore Train Whitney, was a large Greek Revival house that had a colonnade of five Ionic columns supporting a projecting pediment, which served as additional living space in the attic. Superbly placed on a knoll overlooking the Neponset River, the popular resort catered to those who might "wish to live outside of the city in the spring before opening their country houses for the summer, or in the autumn before moving into town for the winter." On the right is the Baker Mill of Baker's Chocolate, designed by Winslow & Wetherall and built in 1888. (Courtesy Milton Historical Society.)

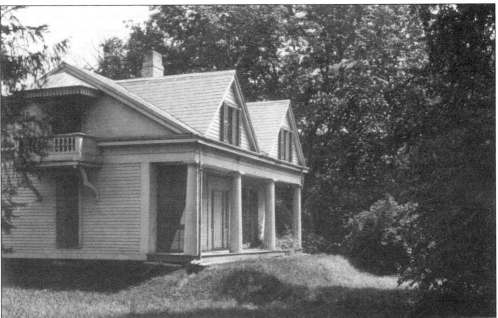

Benjamin Franklin Dudley (1805–1890) built this Greek Revival cottage in 1835 on Adams Street. A simple, one-story house with twin pediments, it had a reeded Doric colonnade. The house was modernized in the 1860s with the addition of a small balcony with a cutwork wooden awning on the left. Dudley was in the granite business, being associated with the Quincy Granite Company from 1835 to 1850, after which he farmed his land on Milton Hill. (Courtesy Milton Historical Society.)

The Todd-Tudor House was built in 1830 at 51 Randolph Avenue. Built by Robert McIlvaine Todd (1802–1890), who owned a lumberyard in Milton Village, the designs are taken from Asher Benjamin's book *The Practical House Carpenter*. The one-story Greek Revival wood-framed house has a colonnade of four fluted Doric columns supporting a cornice and a projecting roof, which is punctuated by three dormers. A bay window was added to the left of the front entrance and a right wing for the office of Dr. Frederic Tudor, who owned the house in the mid-20th century. Dr. Tudor was the possessor of Massachusetts license plate No. 1, probably the ultimate status symbol.

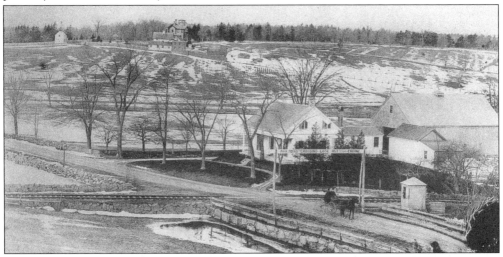

Looking northwest from Granite Avenue *c.* 1885, the Fenno House in the foreground was adjacent to the railroad crossing of the Granite Branch, New York, New Haven, & Hartford Railroad. Squantum Street is in the foreground and the open fields lead to the Edward M. and Alice H. Forbes Cary House, seen in the center distance on Cary Hill. The Cary Estate was later subdivided after the death of Edward M. Cary (1828–1888), with Cary Avenue, Cabot Street, Pillon Road, Taff Road, Augusta Road, Hurlcroft Road, and Father Carney Drive being cut through the estate. (Courtesy Milton Historical Society.)

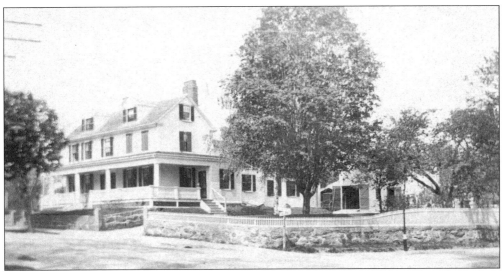

The Durrell-Talbot-Severance House was built *c.* 1831 at the corner of Canton Avenue and High Street. John and Henry Durrell operated a stage from the Lower Mills to Boston and later owner Dudley Talbot was the owner of Talbot's, a fine grocery and provision store in the Lower Mills. Today, this is the headquarters of De Wolfe Real Estate. (Courtesy Milton Historical Society.)

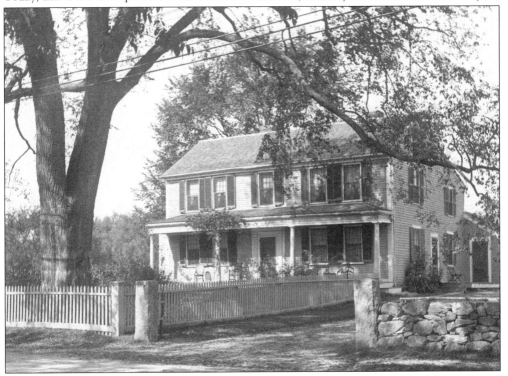

The Ebenezer Tucker House was built in 1831 on Canton Avenue opposite Mingo Street. Similar to the Durrell-Talbot-Severance House at Milton Village, this five-bay façade Greek Revival house originally had a colonnade of four thin Doric columns supporting a cornice. Today, the front porch has been removed and there is a superb perennial garden in front of the house. (Courtesy Milton Public Library.)

This carpenter-built Greek Revival house precisely follows the designs outlined in *The Practical House Carpenter*, the pattern book published by Asher Benjamin, or *Civil Architecture* by Edward Shaw. Built c. 1840, this wood-framed house has four Doric columns supporting a portico, corner pilasters, and a pedimented gable facing the street. Although located at 657 Pleasant Street, the house was moved from the corner of Adams Street and Cary Avenue just after World War II when Cary Avenue and Cabot Street were laid out.

The Tilden-Bradlee-Morris House is a Greek Revival structure built c. 1850 at 175 School Street. Distinguished by its floor-length parlor windows, columned entrance, and tranceried lunette attic window, it was probably built by its first owner, local carpenter George Tilden. The house was later owned by Charles Morris, son-in-law of Edward C. Bradlee, a former president of the Milton Historical Society.

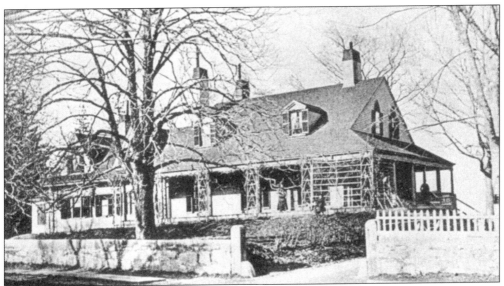

"The Cottage" of John Malcolm and Sarah Coffin Jones Forbes was at 240 Adams Street. Originally built for Henry Sturgis and Mary Hathaway Forbes Russell, who later moved to Wigwam Hill on Canton Avenue, it was described as having "a beautiful view of the harbor from the back windows and the house nestles down so cosily."

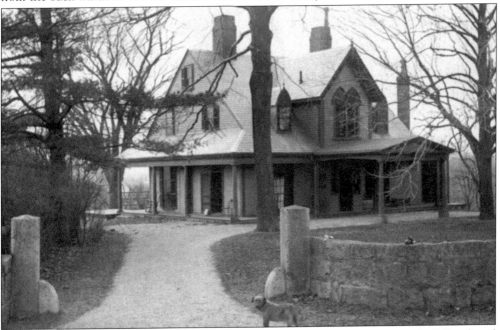

Deacon Samuel Adams (1791–1879) purchased this house in 1829 at Marshall Road and Highland Street. Samuel Adams was a member of the Boston Rangers, a local militia group, serving in the War of 1812. He purchased the bakery of Josiah Bent in 1834, thereafter greatly increasing the business. The Adams House has a Doric-colonnaded porch that extends along three sides of the house with lancet-shaped windows and dormers. The floor-length windows on the first floor and the projecting porte cochere make for a Greek Revival elegant house verging on the Gothic Revival. (Courtesy Milton Public Library.)

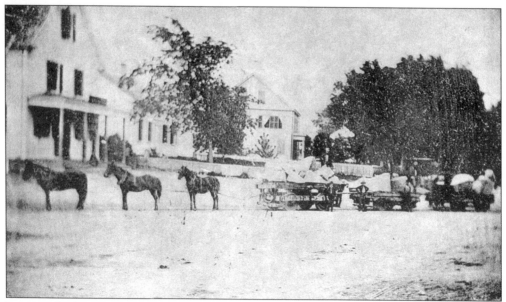

In a view looking south on Adams Street at East Milton Square c. 1860, a horse-drawn railroad of granite crosses Adams Street, headed for Granite Avenue. The houses were on the north side of Adams Street between Granite Avenue and Franklin Street. The 2.75-mile route of the Granite Railway was from the quarries in Quincy along what is now Willard Street to Granite Avenue. From there, it went to the wharf on the Neponset River, where loads would be floated by barge to Boston. (Courtesy Milton Historical Society.)

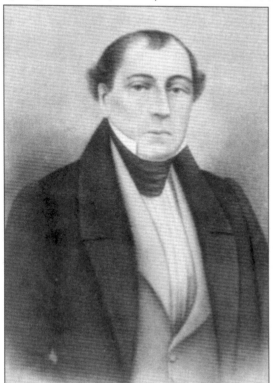

Gridley Bryant (1789–1867) was the projector and engineer of the Granite Railway, the first railroad in America, and the inventor of the eight-wheel car, the portable derrick, and many other important improvements in railway machinery and equipment. The Granite Railway opened on October 7, 1826. Gridley Bryant had purchased the "Bunker Hill" quarry from Frederick Hardwick for the stone to be used for the Bunker Hill Monument, which was designed by Solomon Willard (1783–1861).

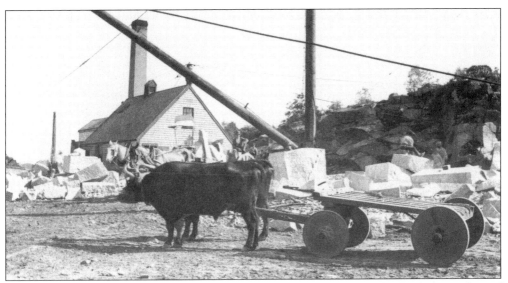

An ox team stops at the quarry before granite is loaded onto the flatbed. The first president of the Granite Railway was Thomas Handasyd Perkins, a wealthy merchant whose munificence benefited both the Boston Athenaeum on Beacon Hill and the Perkins School for the Blind in South Boston. Perkins, William Sullivan, Amos Lawrence, Solomon Willard, David Moody, and Gridley Bryant had successfully petitioned the legislature, and the corporation became an entity on March 4, 1826. (Courtesy Milton Historical Society.)

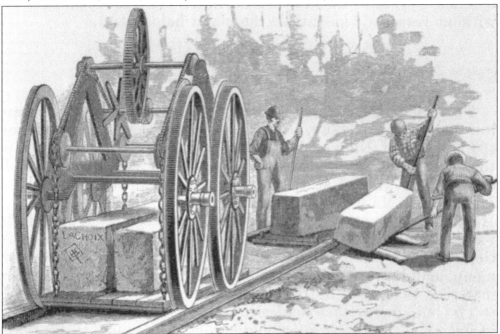

Workers hoist granite blocks onto a flat platform placed between the tracks that would be attached with four chains to the railroad cars. Using a winch, the platform holding the granite block would be raised, and the load would be suspended between the wheels of the railroad car. Horses or oxen would then pull the car to the wharf on Granite Avenue just north of East Milton Square. This procedure is considered to be the first railroad in America.

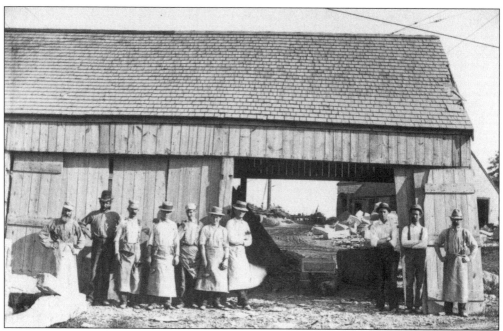

Leather-aproned stonecutters pose outside a stonecutting shed where large blocks of granite were dressed before being shipped to the building site. (Courtesy Milton Historical Society.)

The stonecutting shed of Maguire O'Heron Granite Works was a long, one-story building where granite pieces were prepared for use in buildings, walls, and foundations. This shed was on Granite Avenue near Mechanic Street. The spire of the East Milton Congregational Church can be seen in the distance. The church on Adams Street ceased as a place of worship in 1951, when a new church was built across the street at Adams and Church Streets. The former church was later used as the Milton Elks Lodge and has now been converted to condominiums. (Courtesy Milton Historical Society.)

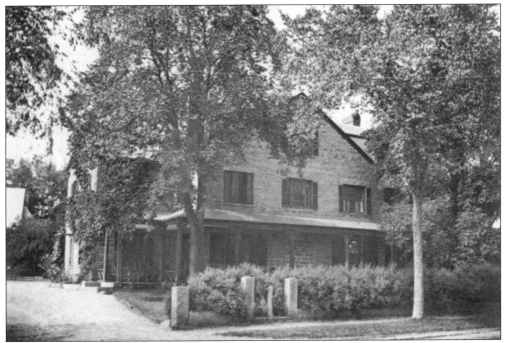

The Railway House was built in 1826 on Adams Street as a tavern and inn catering to the throngs of people who traveled to see this novelty. Known as the Blue Bell Tavern, the rough-hewn granite inn once stood on the site of the Milton Post Office at East Milton Square. Thomas Hollis Jr. (1801–1873), for whom Hollis Street was named, lived in the stone house at East Milton and served as president of the Granite Railway Company. (Courtesy Milton Public Library.)

The Howe House was built on a knoll at the corner of Randolph Avenue and Reedsdale Road. Joseph N. Howe built this house c. 1830 using wedge-shaped pieces of granite quarried in Quincy. The house, enlarged with two shed-type dormers of the early 1940s, is now rented as a private residence and still stands opposite St. Elizabeth's church. (Courtesy Milton Public Library.)

The blacksmith and wheelwright shop of Luther Felt was built at 416–418 Adams Street at the corner of Squantum Street. It was here that all of the wheelwright and ironwork required in the construction of the granite railway cars were wrought. Not only was the first floor of Felt's shop built of granite, but also a wall of granite blocks bordered the property. By 1887, the shop was converted to the residence of George W. Hall. (Courtesy Milton Public Library.)

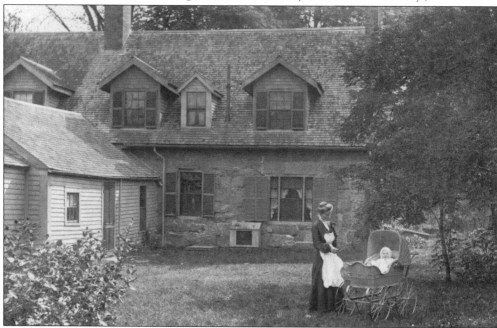

A mother, possibly Mrs. Ernest W. Bowditch, who lived here in the late 19th century, admires a baby in a perambulator behind the former Luther Felt blacksmith shop. A large granite building constructed of blocks of hewn granite, it was converted to a residence that was first occupied by George W. Hall and later by Ernest W. Bowditch, a well-known landscape architect and designer of the Milton sewer system. Notice the wood doghouse between the first-floor windows. (Courtesy Milton Historical Society.)

Six

ITALIANATE
ARCHITECTURE

The Italianate style, which includes the Gothic Revival style, was the virtual incarnation of the Romantic historical past and the use of architecture to re-create the spirit of an earlier time. Andrew Jackson Downing (1815–1852) espoused this style with the use of lancet-shaped windows, verge boards, pendills, and drops with intricate tracery and detail. The Gothic Revival style began in the early 1840s and was often disseminated through pattern books, among them Downing's books, *Cottage Residences* and *The Architecture of Country Houses*. Another pattern book was Calvert Vaux's *Villas and Cottages*, which could be adapted to the tastes and budgets of the public. Milton has a few surviving examples of Gothic Revival architecture, the most prominent being the Cornell-Worch House on Brook Road near Mattapan.

Often embracing the Romanticism of the 1840–1855 period, architects designed villas in country-like towns for those seeking repose from the burgeoning city. This style of architecture was, according to Roger Kennedy, "harmonious with nature because its shapes were natural, its rooflines pitched in parallel to arching trees, its eaves carved like vines . . . its chimneys prominent like ancient cottages, its colors . . . chosen to blend with the natural hues about it." Gothic Revival architecture often reflected the character and personality of the resident. This, according to Downing, signified that "truth, beauty, strength, spirit, naturalness and picturesqueness should be embodied in American architecture as a direct reflection of America's national character." Most Gothic villas were built as summerhouses for those who lived in Boston during the season, inviting nature to enshroud it. In this regard, the houses were less prepossessing or impacting on local architecture.

The Italianate style was to become fashionable in the 1860s with the influences of the Second French Empire, when Napoleon III ruled France. In the 1860s the mansard roof, so common in the chateaux of the Loire Valley, was reintroduced as to what became the roof style of fashion. The Italian villa, with its board and batten exterior, ample verandas, and bay windows, was perceived as picturesque, natural, and truthful in line and mass. They consequently proliferated in city, suburb, and country. The style, probably best exemplified by the now lost Kidder House on Adams Street on Milton Hill, was an embodiment of unbalanced massing with gabled roofs, bracketed eaves, rounded-arch windows, a projecting tower, balconies, and bay windows—all of which combined to present the varied characteristics of this style of architecture.

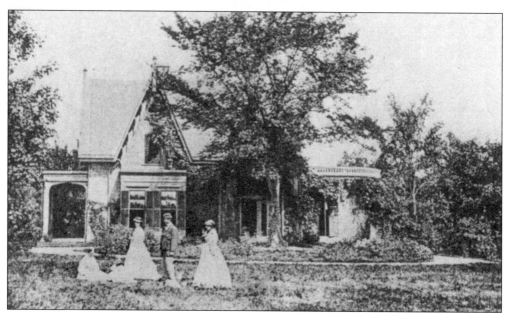

The Robert S. Watson House was a Gothic Revival cottage at 271 Adams Street. Built by Robert and Mary T. Hathaway Watson, a twin sister of Sarah S.H. Forbes, their house and that of John Murray and Sarah S. Hathaway Forbes were often referred to as the "Twin Cottages." As said by Andrew Jackson Downing in his book *The Architecture of Country Houses*, "when smiling lawns and tasteful cottages begin to embellish a country, we know that order and culture are established." William Ralph Emerson later remodeled the Watson House in 1872 with Shingle-style details. It was demolished after World War II.

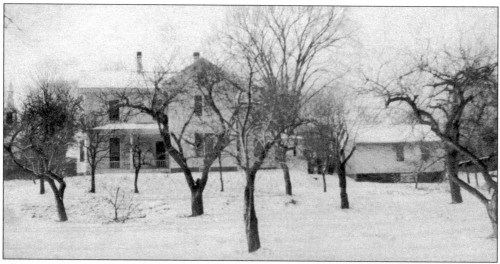

The Reed-Draper-Donahue House is a "square, stiff" Italianate house at the corner of Reedsdale Road and Canton Avenue. Built in 1838 by Samuel Cozzens, it was later purchased by Jason Reed (1794–1873) and known as Redesdale "in memory of the old home in England." It had extensive lands that included what is now Lantern Lane. In 1938, Aimee F. Draper built her own residence adjacent to that of her parents at 104 Reedsdale Road. In recent history, it has been the home of the Donahue family, Dr. Donahue keeping his dental office here. (Courtesy Milton Historical Society.)

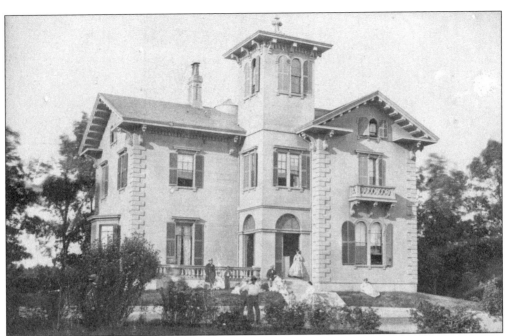

The Frothingham-Kidder House was a heavily bracketed Italianate villa, possibly designed by Nathaniel J. Bradlee. Built c. 1855 by Samuel Frothingham on Adams Street, the estate was later purchased in 1872 by Caroline and Henry P. Kidder. The 18-acre estate was approached by an avenue lined with Norway spruces and a 3.5-acre lawn. It was a horticultural showplace and was lavishly planted and tended by numerous gardeners. Nathaniel Kidder, who inherited the estate upon his father's death, had six greenhouses that "showed what could be done in conservatory decoration." (Courtesy Milton Historical Society.)

Henry Purkitt Kidder (1823–1886) was said to be a "genial, philanthropic man especially interested in the improvement of children of the city." An ardent horticulturist, he was a member of the Massachusetts Horticultural Society for 25 years. He was the co-founder—with his summer neighbor, Oliver White Peabody (1834–1896)—of the investment firm of Kidder, Peabody, & Company. His townhouse was designed by Nathaniel J. Bradlee and built in 1870 at 5 Newbury Street in Boston's Back Bay. It was later used as the first headquarters of the St. Botolph Club. (Courtesy Milton Historical Society.)

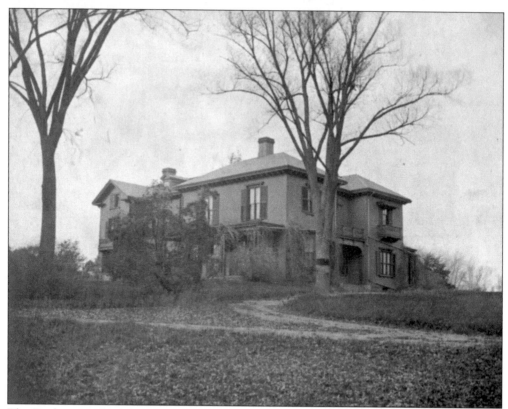

The Birches was the Adams Street estate of Robert Bennet Forbes. Built in 1847 and enlarged in 1852, the house was possibly designed by well-known architect Richard Upjohn. It was a typical Italianate villa that would have been built in the suburbs of Boston. Speculation as to the architect of the Birches has led to a similar design by Upjohn for Edward King of Newport, Rhode Island, who was associated with Russell & Company, headed by Mr. Forbes—so it is plausible that the attribution bears weight. (Courtesy Milton Public Library.)

Robert Bennet Forbes (1804–1885) was the head of Russell & Company, the largest American trading house during the 19th century in China. Beginning his career with his cousins, Samuel Cabot and Thomas and James Perkins, he went before the mast in the ship *Canton Packet* "full of determination to some day command the ship." He retired in 1832 as captain of the *Levant*, which he had taken control of at the age of 20. He returned to China in 1838 and 1849, holding the American vice consulate in China in 1849, while being engaged in the China Trade. In 1847, he headed the relief ship *Jamestown*, which he sailed to Ireland to benefit those afflicted by the great famine.

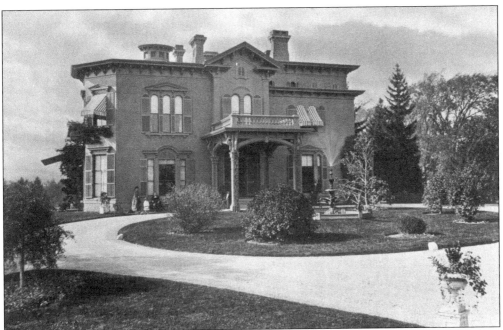

Wayside Farm was the 13-acre estate of John Henry Brooks and ran from Adams Street to Centre Street. An impressive asymmetrical Italianate house, it had a porte cochere projecting from the façade, heavily bracketed cornices, and paired and triple-arched windows. A bracketed cupola had panoramic views of the town. Members of the Brooks family can be seen to the left of the porte cochere. (Courtesy Milton Historical Society.)

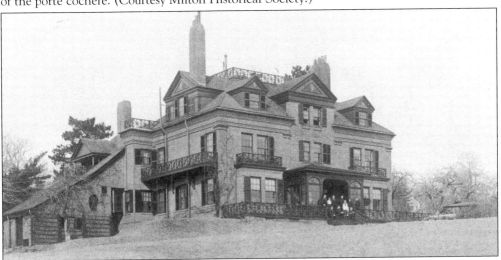

The Hughes House was a large Italianate stone house designed by William Ralph Emerson and built in 1889 on 5.8 acres at 144 Randolph Avenue. J. Murray Forbes built the house for his daughter, Sarah Forbes, and William Hastings Hughes (1834–1907), who were married in 1887. Hughes was a merchant in the Spanish sherry trade and was known as a "thoroughly honorable and upright business man." An impressive brick house echoing the designs of an earlier Italianate house, it had a center pavilion projecting three stories, bold façade pilasters, and intricate balconies. The house later became the home of Weston and Alice Hathaway Forbes Howland. (Courtesy Milton Historical Society.)

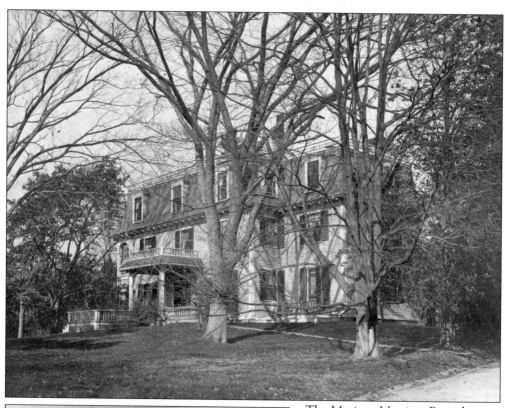

The Morison-Merriam-Partridge House is a bracketed Italianate house that was built at 307 Adams Street. With a fashionable mansard roof, which came into use following the Civil War, the house had a projecting front entrance porch and a dentilled cornice. The Merriam family purchased the house from Reverend Morison, who had moved to Boston. Augusta W. Merriam married William Ordway Partridge.

Reverend John Hopkins Morison (1808–1896) was pastor of the First Parish Church of Milton, serving from 1846 to 1871. A graduate of Harvard and of the Harvard Divinity School, he was a well-known writer. Reverend Morison also served as a trustee of the Milton Public Library. (Courtesy Milton Public Library.)

William Ordway Partridge (1861–1930), called the "Angel of Clay," paints in his studio in 1893 with a life-sized clay model of the equestrian statue of President Grant in the background. Returning from Rome in 1889, he and his wife, Augusta Merriam Partridge, lived on her family's estate in Milton. In his little volume *The Song Life of a Sculptor*, Partridge's sonnets and verses echo his works of art in clay and bronze. Partridge's pet phrase was, "Art is the reflection in the river," meaning that as an artist, he must emphasize the spirit of the person's life and not just record its likeness. (Sammarco collection.)

Teach me, dear Heart,
to love the simple things?

—Partridge

William Ordway Partridge leans on a gate looking toward his studio behind his house at 307 Adams Street on Milton Hill. Just inside the studio doorway is his equestrian statue of Gen. Ulysses Simpson Grant. A track projects from the studio, allowing the statue to be rolled outside in order to work on it. Unveiled in 1896 on Bedford Avenue in Brooklyn, New York, the statue was said to be "the best in existence" and that in such small details as the slant of the hat, the grip of the reins, and the turning of the toe in the stirrup all connoted the likeness of Grant. (Sammarco collection.)

Who sculptures thee must grasp thy human state,
Thine all embracing love must aim to trace.

—Partridge

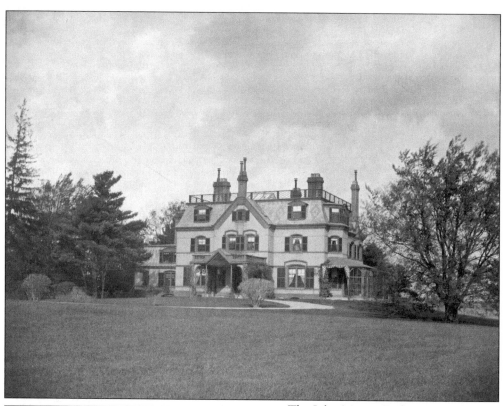

The John Murray Forbes House, known as Fredonia, was a large Italianate house built in 1854 on Adams Street. The house, with a projecting gabled center, has a polychromatic slate roof and is surmounted by a cast-iron roof balustrade. The house was altered and enlarged in 1900 by J. Malcolm and Rose Dabney Forbes, but was unfortunately demolished *c.* 1950. (Courtesy Milton Public Library.)

John Murray Forbes (1813–1898) married Sarah Swain Hathaway (1813–1900) in 1834. A wealthy merchant, he was involved in the China Trade as a clerk. He was later a partner in the house of Russell & Company in China. In the mid-19th century, he was president of the Michigan Central Railroad, and chairman of the Chicago, Burlington, & Quincy Railroad. Forbes owned Naushon Island, a deer hunting ground once owned by the Swains. (Sammarco collection.)

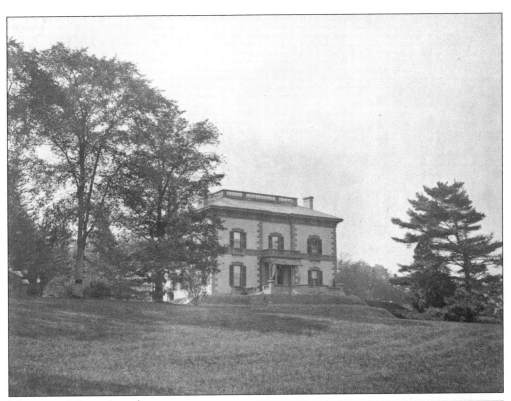

Marion and Amor Leander Hollingsworth's Brushwood was a 92-acre estate extending from Brush Hill Road south to Blue Hill Avenue. A rectangular Italianate house with a projecting center pavilion, Brushwood was distinguished by heavy corner quoining, a roof balustrade, and a balustrade surmounting the entrance. It is thought that this house (demolished at the turn of the century for what is now the MDC Reservation) was part of the original house of Jonathan Jackson, which was built in 1712. (Courtesy Milton Public Library.)

Amor Leander Hollingsworth (1837–1907) was a son of Mark Hollingsworth, co-founder with Edmund Pitt Tileston of the Tileston and Hollingsworth Paper Mill. He served as president of Tileston & Hollingsworth from 1889 to 1907 and served as a trustee of the Milton Public Library. (Courtesy Milton Public Library.)

Benjamin Smith Rotch (1817–1882) built a large Italianate mansion on Blue Hills Parkway (originally Mattapan Street) and Canton Avenue. A wealthy merchant, he was associated with the New Bedford Cordage Company, which he had founded with his brother, William J. Rotch. Benjamin S. Rotch was supportive of the arts and was gifted "with a refined taste and sensitive feeling for form and color" that enabled him to support both painters and sculptors. His former estate (sold to the Town of Milton by his granddaughters, Aimee and Rosamond Lamb) has been recently developed by HOME Inc. as Pine Tree Brook, an elegant senior housing community. The Church of the Holy Spirit in Mattapan was built by his family in Rotch's memory. (Sammarco collection)

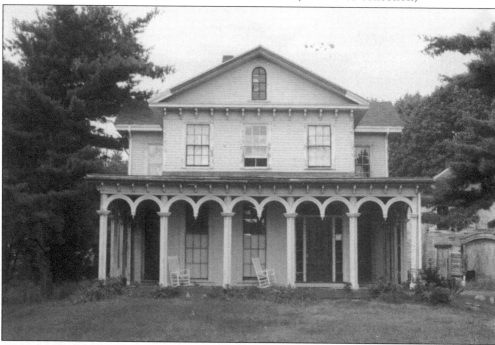

The Cornell-Worch House was built c. 1865 at 150 Brook Road near Mattapan Street (now Blue Hills Parkway). An impressive cross-gabled Italianate house, it has molded arches with pendant drops between quatrefoil colonnettes creating an attractive porch. With heavily bracketed cornices, this otherwise simple wood-framed house becomes quite distinguished. Charles Worch (1851–1931), who purchased the property in 1896, operated a wholesale florist business here until his death in 1931. The owners are currently restoring the details of the house.

The Burt House was built *c.* 1859 by John H. Burt at 167 Brook Road. A two-story wood-framed Italianate house, it is distinguished by corner quoining, an octagonal bay window on the first floor, a double arched window above, and a side entrance supported by squared columns. This house was probably built by the noted builder as his own home. J.H. Burt & Company built the Milton Chemical and Central Firehouses, the Milton lockup (now Milton Yacht Club), and the Church of the Holy Spirit in Mattapan.

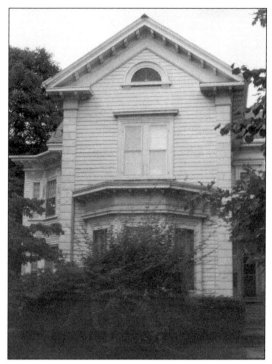

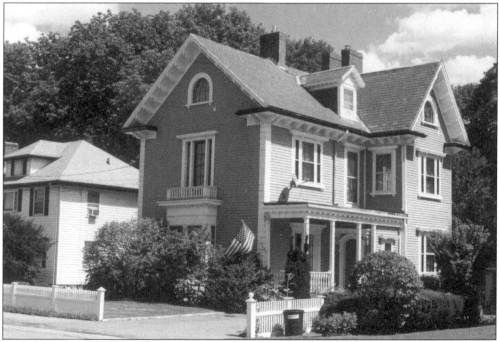

The Joseph Sias House is a two-story side-entrance Italianate house at 25 Centre Street near Centre Lane. Built *c.* 1865 by the grandson of Eliphalet Sias, whose 13-acre dairy farm was adjacent, the house has a cross frame design with heavily bracketed cornices and lintels, corner quoining, and a triple window surmounting the first floor oriole. Sias Lane was the drive to the original house, which was built in 1832 by Eliphalet Sias and still stands at 32 Sias Lane.

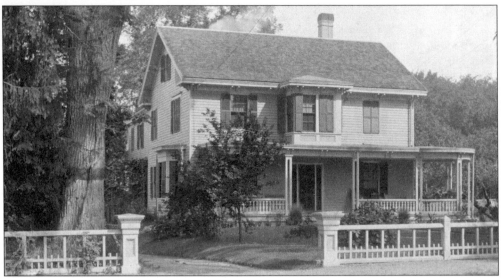

The Rev. Albert Kendall Teele House was built in 1855 at 819 Canton Avenue. Reverend Teele (1821–1901) was pastor of the First Evangelical Congregational Society from 1850 to 1875. Along with committee members James Murray Robbins, Charles Breck, and Edmund J. Baker, Reverend Teele was in charge of writing *The History of Milton*, published in 1887. A well-respected citizen, he served as chairman of the Milton Public Library, chairman of the Milton Cemetery and chairman of the Milton School Committee. It was once said that he was "beloved and esteemed by his fellow-citizens, in full sympathy with a friendly community, and in the serene enjoyment of the delights of the beautiful town he has loved and served so well." (Courtesy Milton Public Library.)

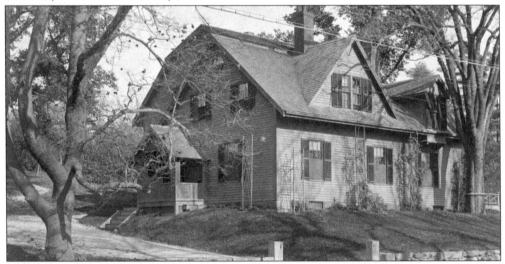

The Ware Cottage was built by local carpenter James Pope in 1844 at 290 Adams Street. A simple Italianate house, it was occupied by the Ware family, including William Robert Ware (1832–1915), who founded the department of architecture at MIT in 1865. Ware was also partner with Henry Van Brundt (1832–1903) in the Boston architectural firm of Ware & Van Brundt. Ware modeled his school on the Ecole des Beaux-Arts in Paris and began to teach American architects the techniques and skills learned abroad in the first and finest professional school in the country. (Courtesy Milton Public Library.)

The Franklin A. Davis House at 241 Canton Avenue is the quintessential Italianate house with its symmetrical façade of center entrance, paired bracketing, arched windows, and its intact sunblinds. Set on a large lot, the house has recently been remodeled with a side entrance that replicates that of the façade, a new fence and other details that re-create the Italianate details of the original house. Davis was a wool manufacturer and his daughter Marion married Amor Hollingsworth.

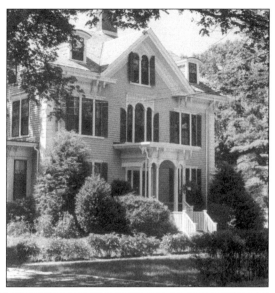

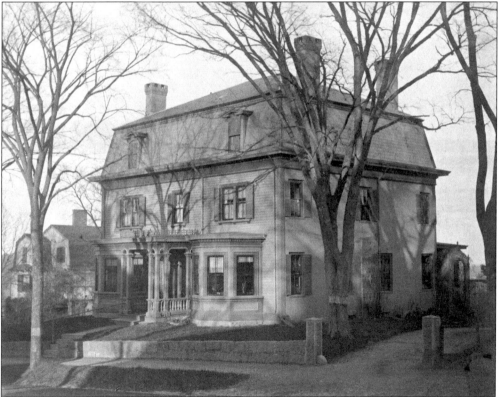

The Glover-Faucon House on Adams Street was modernized in 1865 as an Italianate house with a fashionable mansard roof, symmetrical bays on either side of a projecting porch, and paired windows on the second floor. The second owner of the house was Capt. Edward H. Faucon (1806–1894), a well-known sea captain. The house on the left belonged to Adeline Train Whitney (1824–1905) and was built in 1894 at 134 Adams Street. (Courtesy Milton Public Library.)

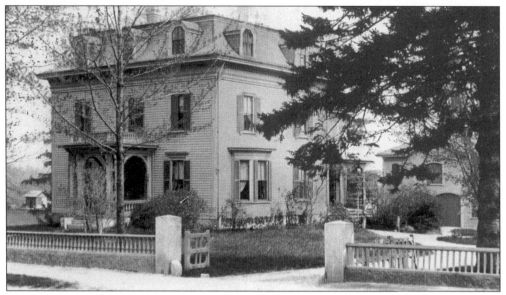

The Babcock-Rowe House was an Italianate house at 454 Adams Street at East Milton. Built c. 1872 with a fashionable slate mansard roof, symmetrically placed windows, and octagonal hooded dormers, the house and its carriage house in the rear stood on 4.5 acres. It was demolished in 1952 to make way for St. Agatha's School. The granite piers marking the carriage drive remain on either side of St. Agatha Road. (Courtesy Milton Historical Society, with thanks to Patricia Susi and Kathleen Lynch.)

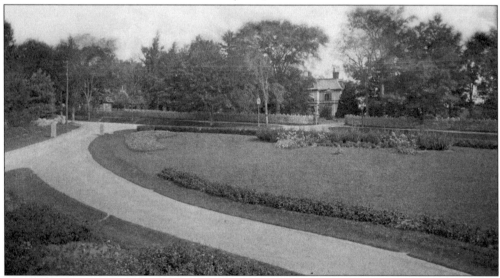

The Angier-Rotch House on Adams Street can be seen through the trees from the estate of Edith Forbes and Charles Elliott Perkins on Milton Hill. Rev. Joseph Angier (1808–1871) was the minister of the Milton Congregational Church from 1837 to 1845. He was described as "a man of rare qualities of heart and mind, genial, sympathizing, full of kindly feeling, and possessed of a high degree of culture." His widow, Elizabeth Rotch Angier (1815–1884), and her sister, Joanna Rotch (1826–1911), jointly built this house in 1872. The women were sisters of Benjamin Smith Rotch, whose estate was on Blue Hills Parkway. (Courtesy Milton Historical Society.)

Seven

VICTORIAN
ARCHITECTURE

The very term "Victorian architecture" creates an image of "gables on top of gables [with] strange openings and curious balustrades! How an architect must have to torture his mind to invent such things." The French architectural critic Jean Boussard made this comment in 1885, and it might aptly be used in reference to some of the houses built in Milton in the 1875–1890 period. In this period (which was eclectic, unique, and individualistic at its best), the noted architectural historian John Ruskin, for whom Ruskinian Gothic was so named, said, "Until common sense finds its way into architecture there can be little hope for it."

Victorian architecture, according to the experts, extends from the coronation of Queen Victoria in 1837 to her death in 1901. This nearly seven-decade period saw tremendous changes in the world, not the least of which was architectural styles. From the Greek Revival and Gothic Revival styles at the beginning of her reign, the Victorian styles also included the Italianate, Second French Empire, Eclectic, Shingle, Queen Anne, and Colonial Revival styles. Each style is an individual one, but in some cases drew on various styles for a composite known as Eclectic architecture.

Milton is indeed fortunate in having numerous examples of Victorian architecture, especially those designed by William Ralph Emerson (1833–1917), who was known as the "Father of the Shingle Style." Edwin J. Lewis Jr. was his successor. Emerson, who designed massive country houses for Milton's 19th-century aristocracy, created a distinct form of late-19th-century architecture that was considered at one with nature. The use of stone, wood shingling, clapboarding, and uniquely shaped windows and dormers all combined to create an impressive design. In many ways, the architects who designed in Milton in this period made unique contributions to the town's architecture: Nathaniel J. Bradlee; William Ralph Emerson; John A. Fox; Peabody & Stearns; Perry, Shaw & Hepburn; Rotch & Tilden; S. Edwin Tobey; and Winslow & Wetherall.

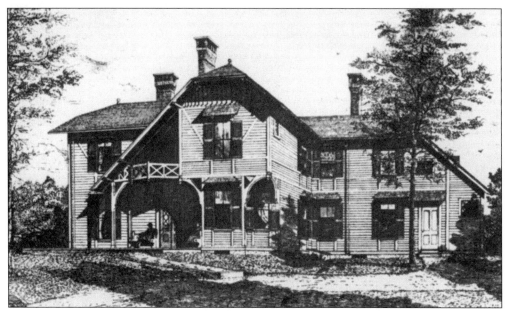

Three Pines was the home of Frances Cornelia and Margaret Perkins Forbes at 7 Fairfax Road off Brook Road. It was designed by William Ralph Emerson (1833–1917) in 1876. Architectural historian Vincent Scully said of this house, "Emerson created at least one extremely sensitive masterpiece in the mid-century stick style." Decidedly Stick-style in design, with framing members evident on the exterior, the house has asymmetrical rooflines and an interesting Stick-style porch, which though remodeled still, is an early representative of Emerson's work.

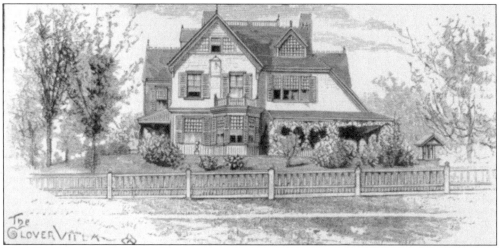

The Theodore Russell Glover House was designed by William Ralph Emerson and built in 1879 on the site of the Foye House at 320 Adams Street. An asymmetrical house with a long side porch with an octagonal bay on the first floor, it had multipaned windows, a roof balustrade, and a prominent sundial just above the second-floor windows. Emerson used clapboarding on the first floor with shingles above, but it was the roof that attracted one's attention. In his book *The Shingle Style*, Vincent Scully mentions this house, saying that the "mountainous sweep of the shingled roof, adjusting itself from gable to gable and then gliding down like a deeply sheltering wing over the piazza must be considered an important and advanced feature of the house."

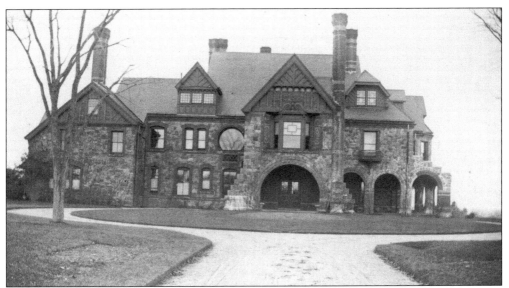

William Ellery Channing Eustis (1849–1932) had his house designed by William Ralph Emerson. It was built in 1878 at 1426 Canton Avenue. Seen from the side driveway, the principal façade has a massive Romanesque Revival arch with buttresses on either side. With the use of stone quarried on the site and fanciful Tudor half-timbering on the gables, the polychromatic brick chimneys and interesting and varied window openings makes this not just a unique house, but Emerson's masterpiece. The numerous stone estate buildings were designed by W.E.C. Eustis, who was an amateur architect, including the stone gate lodge that remains at the entrance to the estate on Canton Avenue. (Courtesy Milton Historical Society.)

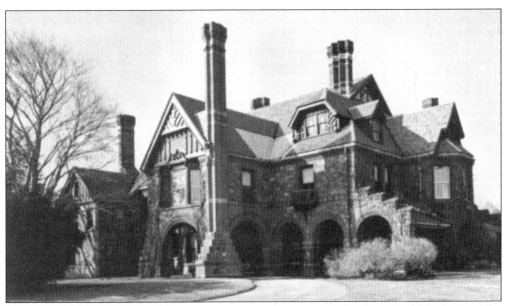

This view of the Eustis House shows its massing with stonework, brick, and half-timbering. The massive roof is punctuated by dormers, and brick chimneys seem to thrust through it. The robust porte cochere, with its massive Romanesque Revival arch, creates a dramatic aspect to the façade. The broken scroll surmounting the window above adds to its architectural interest.

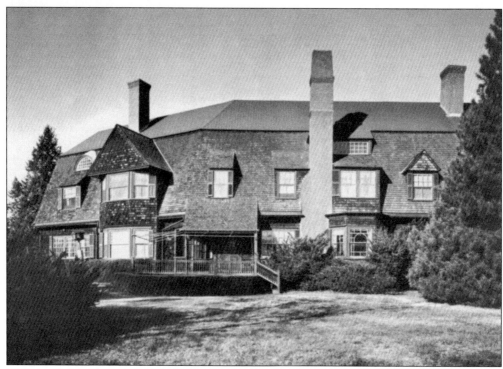

William Ralph Emerson's own house was built in 1886 at 210 Randolph Avenue. It was in effect a one-story Shingle-style house with a massive two-story gambrel roof punctuated by dormers and a two-story bay capped by a pediment. With the use of weathered shingles for both the exterior and the roof, it gave the house a unique sense of individuality as well as a naturalistic appearance for the home of the architect known as the "Father of the Shingle Style." (Courtesy Milton Historical Society.)

Emerson designed the façade of his own house with a Romanesque Revival arch at the entrance with a unique Shingle-style exterior. The house has overhanging second and third stories and banks of windows on all three levels. The similarities between Emerson's own style of architecture and that of First Period Colonial architecture are obvious. He designed both houses and often the furniture for those houses, commingling to create a unified impression of an earlier structure. This massive house was Emerson's home from 1886 until his death in 1917.

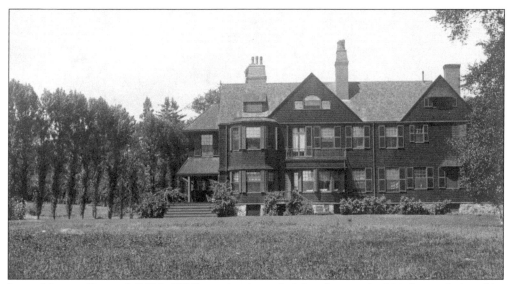

James Munson Barnard (1819–1904), a scientist and philanthropist, had his house designed by William Ralph Emerson. The home was built in 1885 at the corner of Adams Street and Barnard Avenue. Massive pediments that had modified Palladian windows punctuated a two-story Shingle-style house, its roof having dormers of varying sizes with immense chimneys rising above the roofline. The house was later occupied by Roger and Ruth Eliot Pierce, he being a grandson of S.S. Pierce and she a granddaughter of President Eliot of Harvard University. (Courtesy Milton Public Library.)

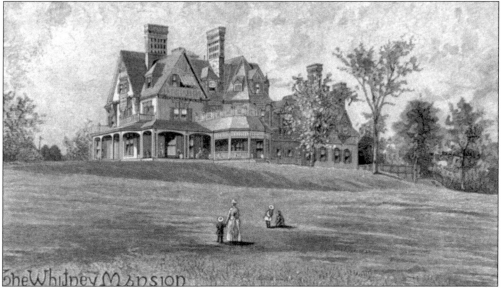

The Fanny Lawrence and Henry A. Whitney House was a massive Victorian mansion at the corner of Blue Hill Avenue and Robbins Street. Described as "an artistic modern structure [that] presents a striking contrast among the buildings of olden times," the house was built c. 1880. The Whitney estate extended from Blue Hill Avenue over Canton Avenue into the meadows and forest beyond. All that survives of this impressive estate is a former estate cottage at 562 Blue Hill Avenue that serves as part of Delphi Academy on Blue Hill Avenue.

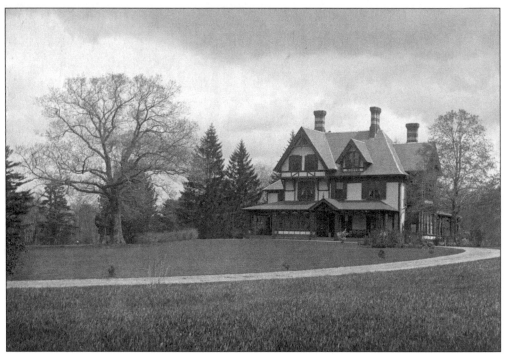

The Russell Estate, known as Home Farm, was built c. 1872 at 750 Canton Avenue, an area that the Neponset Tribe of the Massachusetts Indians is known to have inhabited and called Wigwam Hill. A 304-acre estate that extended to Pine Tree Brook, it was landscaped in 1899 by Olmstead Associates and in recent decades has been developed as Indian Cliffs. The house had a stucco exterior with Tudor half-timbering, creating an interesting post-Medieval country house. The estate had racehorse paddocks, a keeper's lodge, and a glass conservatory. (Courtesy Milton Public Library.)

Henry Sturgis Russell (1838–1905) was colonel of the Fifth Massachusetts Cavalry in the Civil War. Russell, associated with J.M Forbes & Company, later served as police and fire commissioner for the City of Boston and on various town committees. It was said of him, "He discharged his duties in no perfunctory manner, but felt as deep an interest in the public service with which he was identified as though it had been his own private business." His widow, Mary Hathaway Forbes Russell, placed a granite horse trough at the junction of Canton Avenue and Center Street in his memory. (Sammarco collection.)

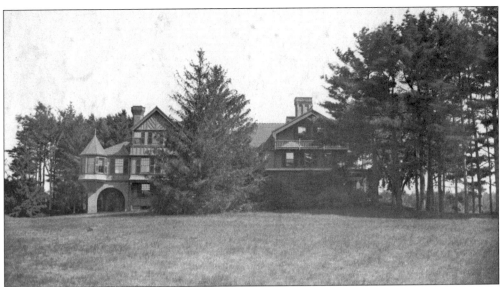

Old Farm was the summerhouse of Mary T.P. Hemenway at 1514 Canton Avenue. Originally an 18th-century house built by the Davenport family, the house was extensively remodeled and added to by William Ralph Emerson in 1877, two years after the death of Augustus Hemenway. Old Farm was remodeled as a country estate with rambling Queen Anne and Shingle-style details. Although remodeled from an earlier house, it retained much of its earlier interior details and individuality as a summerhouse. (Courtesy Milton Public Library.)

Mary Porter Tileston Hemenway (1820–1894) was the widow of Augustus Hemenway. A great philanthropist, Mrs. Hemenway funded domestic arts courses in the Boston Public Schools. Along with sewing, cooking, and sloyd, the manual arts and gymnastics were instituted when she was a member of the Boston School Committee. Although not formally connected with education, she had great influence in shaping its course. It was said that her "benefactions were often far from what a person of her social standing might be expected to think of."

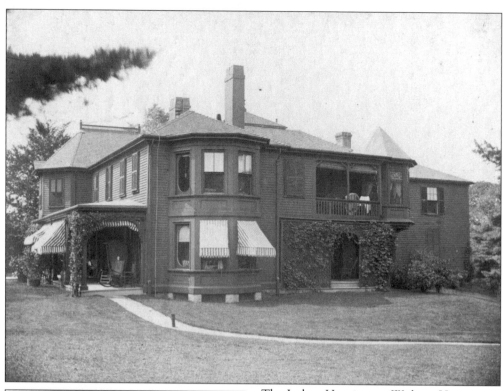

The Joshua Huntington Wolcott House on Canton Avenue was built for Joshua Wolcott (1804–1891), a member of the firm of A & A Lawrence. Wolcott was active on boards of manufacturing corporations and banks, as well as charitable boards. (Courtesy Milton Public Library.)

Henritta L.T. Wolcott (1821–1903) was an avid horticulturist and one of the few female members of the Massachusetts Horticultural Society in the 19th century. Her great interest was in the creation of public interest in window gardens. As early as 1878, she was on a committee to award prizes for window gardens, which it "was hoped to cultivate a practical taste for floriculture, especially among the children of the laboring classes." It was said that "the whole of her life was a charitable mission, especially for destitute girls, wherein her work was inestimable."

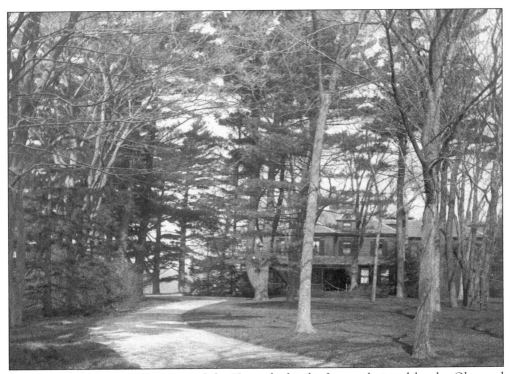

The Pines was the 61-acre estate of the Kennedy family. It was designed by the Olmstead Associates and built in 1885 at the corner of Blue Hill Avenue and Brush Hill Road. Dr. George G. Kennedy and his son and daughter-in-law, Dr. Harris and Frances Keene Kennedy, were noted hybridizers of Japanese iris (often called flower-de-luce) with more than 50 varieties of *Iris Kaempferi* arranged in the Japanese method in their garden. The garden had raised walks around the margins of the beds and was decorated with Japanese lanterns and other garden accessories. (Courtesy Milton Public Library.)

Among the greatest interests of Dr. George G. Kennedy (1841–1918) was botany, with a concentration of New England plant life. An active member of the Massachusetts Horticultural Society, he was also a founder of the New England Botanical Club. The estate, later inherited by his son, was the scene of lavish garden parties, among them one in the Japanese garden in honor of Japan's victory over Russia in 1905. (Courtesy Milton Public Library.)

O, Flower-De-Luce, bloom on, and let
the river linger to kiss thy feet!
O, flower of song, bloom on, and make
forever the world more fair and sweet.
—Longfellow

93

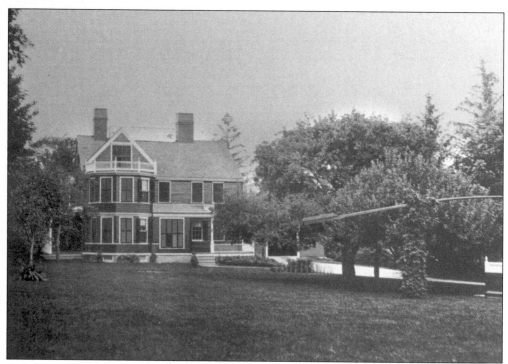

Col. Samuel Swift (1683–1747) built this house at 278 Adams Street. It was remodeled in 1883 by Dorchester architect John A. Fox. Adding on the left an octagonal bay surmounted by a balustrade, a new entrance porch, and a roof balustrade, Fox remodeled a decidedly simple Colonial house with additions that also included a picturesque well on the far right. A portrait of his grandson, John Swift (1747–1819), by T. H. Hinckley is in the collection of the Milton Public Library. (Courtesy Milton Historical Society.)

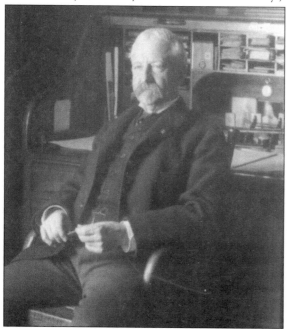

John A. Fox (1833–1920) was a well-known architect who built numerous Stick-style houses in Dorchester in the late 19th century. Apprenticed with the architect B.F. Dwight, Fox established an independent office in 1870 and was a member of the American Institute of Architects. He was to develop a distinct style of architecture that was adapted to both residential and commercial structures. Among his best-known designs were the Globe Theatre in Boston, the Providence Opera House, the Chelsea Academy of Music, and the Carlton Home for Aged Couples in Roxbury (now Carlton Willard Village). His only documented work in Milton was a remodeling of the Swift House in 1883. (Courtesy John A. Fox)

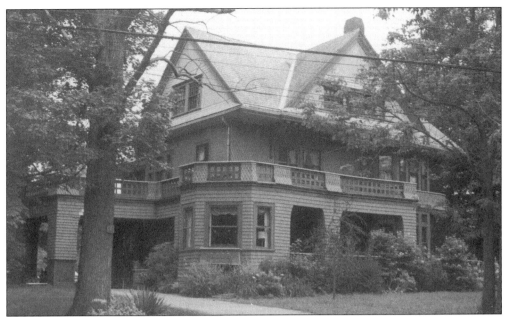

The Puffer-Godfrey House at 44 Randolph Avenue was designed by the noted architect S. Edwin Tobey and built in 1889 for William H. Puffer (1855–1923). With a profusion of details from the varied patterns of wood shingles, stained-glass windows, and a carved panel ornamenting the façade, this impressive multigabled Queen Anne house with its side porte cochere creates a vivid impression of Milton houses in the late Victorian period. Tobey, who was once described as "one of the most skillful as well as successful men in his profession" in Boston, is probably best known for his 1887 Romanesque Revival brownstone and terra-cotta S.S. Pierce & Company building in Boston's Copley Square, demolished in 1955 and now the site of Copley Place.

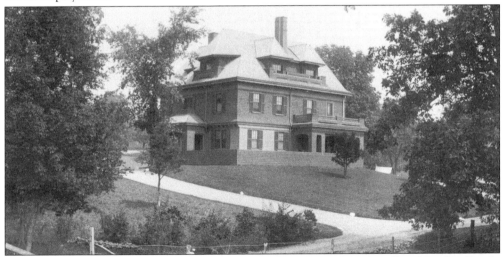

The Boardman-Peabody House was built c. 1887 at the corner of Brush Hill and Bradlee Roads. A large Queen Anne house with clapboarding on the first floor and shingling above, its siting is as commanding as the house. The house was later remodeled by the Boston architectural firm of Parker, Thomas, & Rice. Set on a 6-acre estate, the house was built for W.L.P. Boardman and was later owned by noted attorney W. Rodman Peabody. (Courtesy Milton Historical Society.)

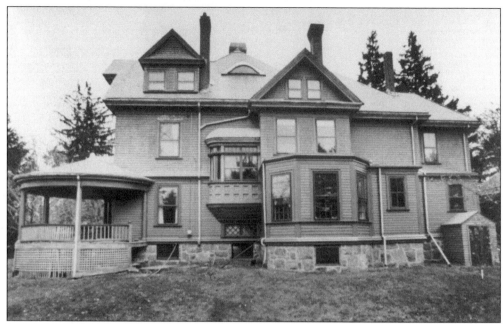

Joseph H. Hall built the Hall-Bush House *c.* 1890 at the corner of Adams and Hutchinson Streets. A large Queen Anne house, the façade had a rounded piazza (left), a number of interesting-shaped dormers, and a fanciful paneled oriole in the center. Built on the site of Unquety, the Gov. Thomas Hutchinson summerhouse, it was an impressive addition to those houses being built on the rise of Milton Hill in the late 19th century. (Courtesy Milton Historical Society.)

George Herbert Walker Bush, president of the United States, was born in the Hall-Bush House in 1924. His parents, Prescott and Dorothy Walker Bush, had rented the house while in the area on business. Prescott Bush was in the rubber business in South Braintree, Massachusetts, at this time and lived here until 1926, when they returned to Connecticut. Prescott Bush later served as a U.S. senator from Connecticut.

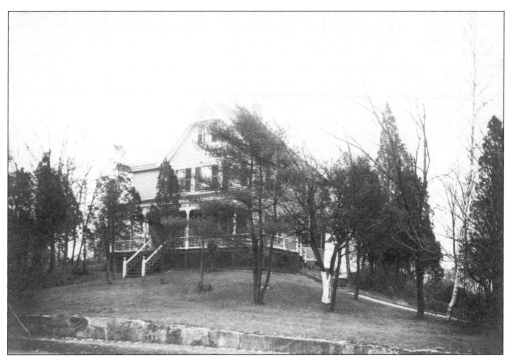

The Martin House was built in 1886 at 64 Maple Street on a knoll overlooking the street. A large Victorian wood-framed house built for Henry and Ella Pope Martin, it had interesting Stick-style details—rectangular balustrades along the piazza, a triangle of wood latticework at the gable peak, varied patterns of shingles, and detail work along the porch cornice. Henry Ballard Martin (1835–1927) served as town clerk of Milton for four decades, retiring in 1913 at the age of 78. (Courtesy Milton Historical Society.)

Micah Dyer Jr. (1829–1917) was a local land developer who laid out Dyer Avenue off Blue Hills Parkway. An attorney and trustee of estates, it was said of Dyer that "the integrity of his administration gained him high esteem." Dyer lived in a large house at Upham's Corner in Dorchester. A generous man, he did "much benevolent work in a quiet way and unostentatiously . . . expended thousands of dollars in rendering life easier [for] the poor, the sick, and the unfortunate." Dyer was one of many non-residents who purchased land in Milton on speculation in the 1880–1910 period. (Sammarco collection.)

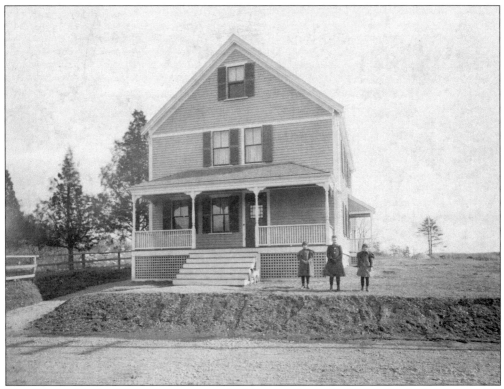

The Thomas Gordon House was a vernacular Victorian house built on a third of an acre at 183 Pleasant Street opposite Gun Hill Street. Often, builders and contractors rather than architects built these late-19th-century houses. This house was a rectangular wood-framed house with a piazza on the front. The children of the house pose on the front lawn, which is terraced down to Pleasant Street. (Courtesy Milton Historical Society.)

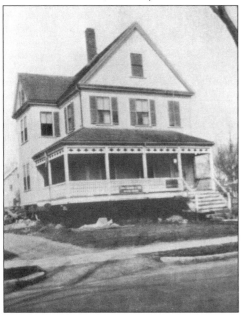

The Kidder House of the Milton Public Library was a carpenter-built Victorian one-family house at 101 Blue Hills Parkway near Mattapan. A two-story wood-framed house, it had gables on four sides for additional living space in the attic. A front porch, or piazza, extended along the façade and had decorative millwork between the posts. The former residence was used as the Kidder Community Center, which was incorporated in 1910 by Nathaniel T. Kidder, M. Vassar Pierce, Nathaniel Stone, Harry K. White, and Roger Wolcott. It served as a branch library between 1911 and 1929, when a new library designed by Eliot T. Putnam replaced it. The old library was moved to 24 Blue Hill Avenue; it was reconverted to a residence and sold by the town.

Eight
COLONIAL REVIVAL ARCHITECTURE

The Colonial Revival period began during the centennial of the United States, when a major exhibition in Philadelphia in 1876 extolled the virtues of our colonial past. Antique furniture, decoration, and housing styles began to draw on America's colonial past, with the broad-based interpretation of Colonial Revival architecture being the result.

In the last decade of the 19th century, architects began to reproduce almost exact replicas of well-known houses built in the 18th and early 19th centuries. Representations of the Hancock House (1737) on Beacon Hill, the Ropes House (1780) in Salem, and the Peter Crafts House (1809) in Roxbury were built for an architecturally aware public seeking to connect with their cultural roots. In many ways, Milton's Colonial Revival architecture began in the 1880s with the Charles Elliott Perkins House (designed by Peabody and Stearns). It continued into the post–World War II years with the Crosby-built houses (designed by Royal Barry Wills) that were intended to compliment actual Colonial examples.

The Colonial Revival period, literally a reviving of a well-known style of architecture, was often more bombastic than its original examples. The use of heavily dentilled cornices and pediments, symmetrical façades, corner quoining and pilastered façades, roof balustrades, and multipaned windows were all used to create a period-styled house. The Colonial Revival also includes the later Shingle style, especially in its interpretation by Edwin J. Lewis Jr. It was described by architectural historian Henry-Russell Hitchcock as the "characteristic use of shingles as an all over wall-covering emphasizing the continuity of the exterior surface as a skin stretched over the underlying wooden skeleton of studs." The Shingle style would continue into the 20th century. Some architects and their firms designed houses that set the tone for future house design in Milton. Among them were Bigelow and Wadsworth, Ralph Lincoln Emerson, Joseph Tilden Greene, Frank Trevor Hogg, Paul Hunt, James T. Kelley, Addison LeBoutillier, Joseph Daniels Leland, Edwin J. Lewis Jr., Harry B. Little, Peabody and Stearns, Eliot T. Putnam, Arthur Wallace Rice, George F. Shepard Jr., Wales and Holt, and Royal Barry Wills. The Colonial Revival style is often interpreted either literally or objectively. It can be full-blown or pared-down, but it always echoes back to our colonial past.

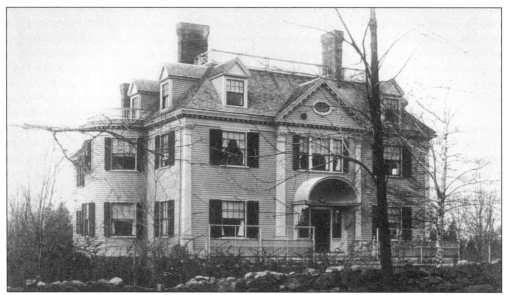

The Roberts House at 70 Centre Street was designed by James T. Kelley (d. 1929) and was built in 1893. It was designed as a high-style Colonial Revival house with full-blown details such as Corinthian corner pilasters, a shell-coved entrance entablature, and a Chippendale-inspired roof balustrade. It was representative of not just Kelley's architectural style, but the taste of his clients that determined the design. After 1915, Mrs. George French Roberts deeded this house to her son and his family and had Kelley and Graves design a Craftsman-style dower house next door at 79 Vose's Lane. (Courtesy Edith G. Clifford)

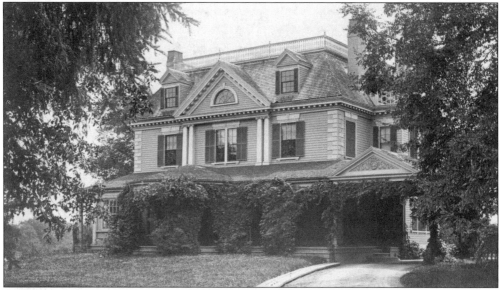

The Charles Barnard House was built *c.* 1875 at 105 Centre Street opposite Vose's Lane. The house was "enlarged and improved" by owner George Bruce Upton in 1889 and had a porte cochere added with impressive corner quoining, bracketed cornices, a pediment supported by paired Ionic pilasters and a balustrade surmounting the hip roof. After 1918, the house was owned by the Viscount P. deFontenilliant, Upton's stepson. After 1928, it was known as Upton House, a part of Milton Academy. (Courtesy Milton Public Library.)

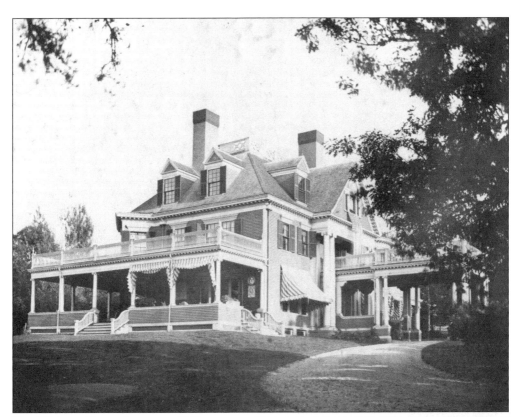

The Wolcott House, known as Hill Farm, was an 1889 remodeling of the original Victorian house owned by Joshua Huntington Wolcott. An impressive Colonial Revival designed mansion, with a porte cochere of paired Ionic columns, it was set on a 100-acre estate at 1733 Canton Avenue. Joseph Daniels Leland (1885–1968) further remodeled the house in 1934 as an impressive Colonial Revival stucco mansion. (Courtesy Milton Public Library.)

Roger Wolcott (1847–1900) served as both lieutenant governor and governor between 1892 and 1898. A well-respected citizen of public spirit, he won the gubernatorial election in 1896 by a record majority, carrying every city and town but one in the commonwealth. It was said of him, "By reason of his natural gifts enhanced by study [he] is peculiarly fitted for the duties of public life." (Courtesy Milton Public Library.)

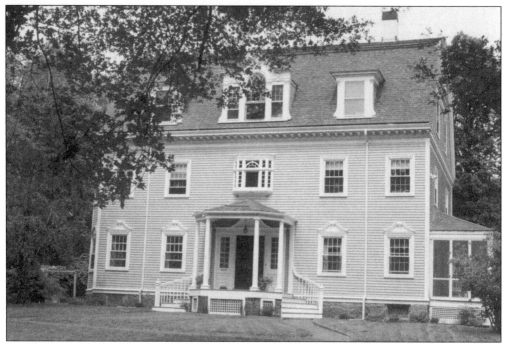

The Pierce House was built in 1883 by local builder Frederick M. Severance on the triangular property bound by Canton Avenue and Centre Street. A large Colonial Revival house with a gambrel roof, its use of classical details (dentilled molding, broken scroll decoration, an oriole, and a modified Palladian dormer window) create an elegant and refined design popular in the late 19th century.

Dr. Matthew Vassar Pierce (1855–1937) moved to Milton in 1882. Pierce, a son of the noted merchant and gourmet food purveyor S.S. Pierce (pronounced *purse*), graduated in 1880 from the Harvard Medical School and pursued further medical study in the hospitals of Vienna, Berlin, and Heidelberg. In 1903, he was one of the incorporators of the Milton Convalescent Home, later to become the Milton Hospital, serving as chief of staff from 1905 to 1936. It was said that he "carried comfort, skilled care, unfailing kindness, sympathy and understanding to practically every member of town, at one time or another." (Courtesy Frances Pierce Field.)

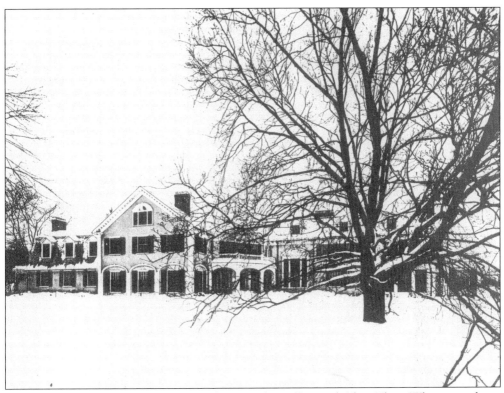

Winter Valley was the Colonial Revival estate of Geoffrey and Alice Thaw Whitney and was designed by Milton architect George F. Shepard Jr. (1865–1955). Built on a large lot at the corner of Canton Avenue and Highland Street, the estate grounds were designed between 1927 and 1934 by Olmstead Associates, the successor firm to the great landscape architect Frederick Law Olmstead. The house had a central pavilion with windows set in arcades, flaking wings, and classical details, such as modified Palladian windows and a heavily bracketed cornice. (Courtesy Milton Historical Society.)

Looking from the garden through an arbor, this view shows Winter Valley, a comfortable and well-designed estate that used classical details and combined architecture and landscape as one design. Shepard was the son of builder George F. Shepard (1827–1908) and a partner with Frederic Baldwin Stearns in the architectural firm of Shepard & Stearns. He also served on the Milton Art Commission. The house was demolished c. 1975, and the property was developed with apartment buildings for senior residents of Milton—a complex appropriately called Winter Valley. (Courtesy Milton Historical Society.)

Addison Brayton LeBoutillier (1872–1951), a native of Utica, New York, was basically a self-trained architect. He moved to Andover, Massachusetts, in 1905 and was associated with Hubert G. Ripley in the architectural firm of Ripley & Boutillier. As an architect, he was said to be among the first to produce cardboard models of his designs for clients. Also a designer of tiles, he was chief designer at the Grueby Faience Company of Boston, producing tiles that were used at St. John the Divine in New York. LeBoutillier also designed the Bernard Trafford House at 118 Woodland Road, off Canton Avenue in Milton. (Courtesy Martha T. Curtis.)

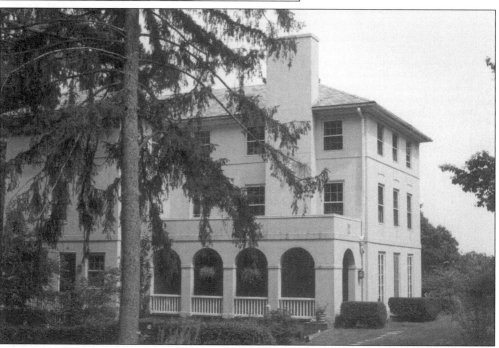

The Perkins House (built in 1912 at 54 Bradlee Road) was designed by Addison Brayton LeBoutillier for John Forbes and Mary Coolidge Perkins. Designed in the manner of an Italian villa, the stucco house is sited on a knoll overlooking both Bradlee and Brush Hill Roads. An arcaded loggia on the left serves as the principal entrance, which is lined with wall sculpture, creating the impression of an Italian villa. In the center of the drive is a large planter designed by LeBoutiller and made by Greuby Faience Company.

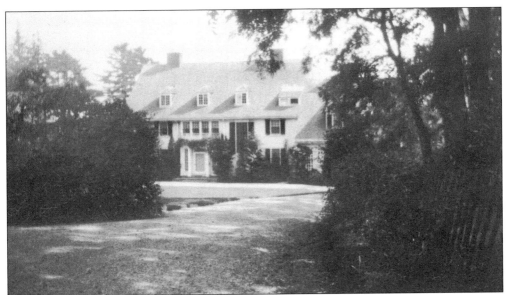

The Charles Elliott Perkins House was designed by the architectural firm of Peabody and Stearns and built in 1881 on a 5.5-acre estate at 255 Adams Street. An impressive Colonial Revival design, the symmetrical house has a wing with a two-story window for the stair hall. Charles E. Perkins (1840–1907) was president of the Chicago, Burlington, and Quincy Railroad, founded by his wife's uncle, John Murray Forbes. This was a summerhouse, as Perkins had a townhouse at 223 Commonwealth Avenue in Boston's Back Bay and a house called the Apple Trees in Burlington, Iowa. (Courtesy Milton Historical Society.)

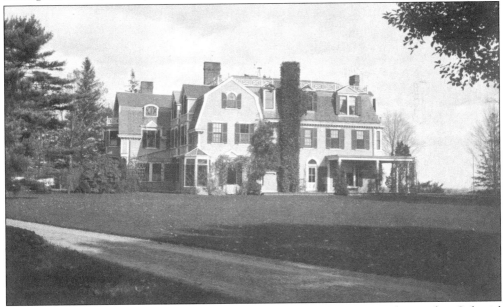

William Hathaway Forbes (1840–1897) had William Ralph Emerson design this Colonial Revival house, which was built in 1891 and was set on a 16-acre estate at 172 Adams Street. Forbes was a businessman and served as president of what eventually became known as the American Telephone & Telegraph Company. The house is modeled in the Colonial Revival style with gambrel gables and two-story bay windows. (Courtesy Milton Public Library.)

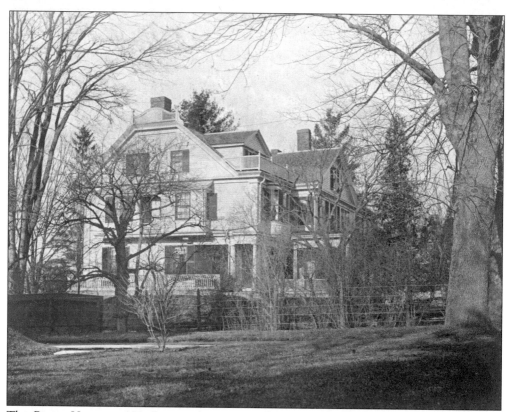

The Pierce House at 103 Canton Avenue was built *c.* 1844 by local carpenter Francis H. Campbell as a Greek Revival house. The house was greatly enlarged and remodeled in 1896 by local builder Frederick M. Severance with impressive Colonial Revival details such as a pedimented entrance with paired Doric columns, bay windows, a plethora of decorative balustrades, and a glass conservatory. (Courtesy Milton Public Library.)

Edward Lillie Pierce (1829–1897) graduated from Brown University and Harvard Law School. A noted historian, his two-volume biography of the statesman Charles Sumner, *The Memoirs and Letters of Charles Sumner*, is still thought to be the definitive book ever written on the abolitionist, senator, and personal friend. Pierce was the brother of Henry Lillie Pierce, who owned the Walter Baker Chocolate Company from 1854 to 1896. A member of the House of Representatives, Pierce was appointed assistant-treasurer of the United States by President Hayes, but declined the appointment. It was said that he "has ever taken an active part in public affairs, where his influence is always felt on the side of all good measures." Pierce served as moderator of Milton Town Meeting, which was also held by his son, Charles Sumner Pierce. (Courtesy Milton Public Library.)

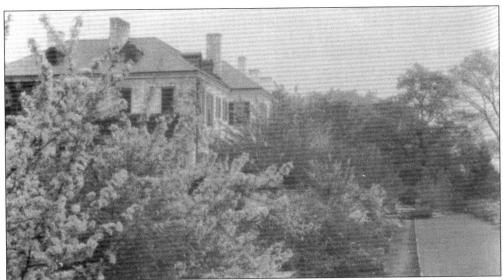

The estate of Gertrude Holden McGinley was at 582 Blue Hill Avenue on a part of the former Whitney Estate. The architectural firm of Bigelow and Wadsworth designed the whitewashed-brick Colonial Revival house. The views of the Blue Hills over open meadows were superb, and "the westward view to the hills through the unceremonious opening in the wall invited the imagination into the pastoral scene beyond, the garden outside the garden." (Courtesy Judith B. Tankard.)

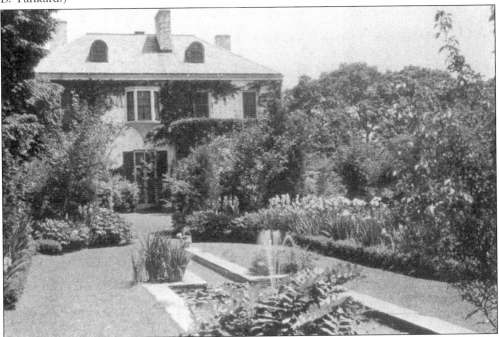

The McGinley garden, designed by noted landscape architect Ellen Biddle Shipman, extended south from the house and included a bluestone-edged rill in the center of a lawn bordered by a garden of peony, iris, and chrysanthemum. Adjacent to this garden was the formal walled garden, which had as a centerpiece a bronze figure by the sculptress Anne Coleman Ladd. (Courtesy Judith B. Tankard.)

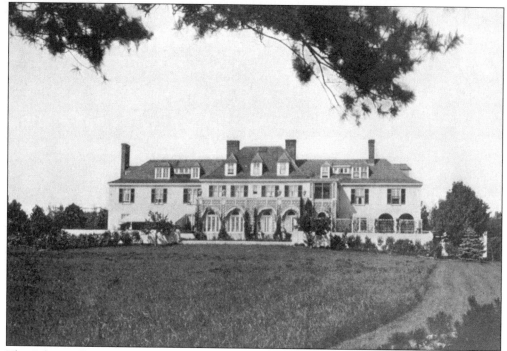

The Saltonstall House was designed by Bigelow and Wadsworth and built on Milton Street. A massive house with a central pavilion flanked by wings, the terrace façade had an arcade of neoclassical trelliswork, surmounted by wood urns, arching over the floor-length windows that opened onto the terrace. The massive roof was punctuated by dormers and overlooked landscaped grounds and formal gardens. (Sammarco collection.)

Robert Saltonstall (1870–1938) was associated with the firm of Charles E. Rogerson & Company, cotton brokers in Boston. Later a trustee of the Cabot Estate, he served as a trustee of the Milton Public Library from 1915 to 1927. (Courtesy Milton Public Library.)

The Robert and Leonore Cobb Amory House was built at 956 Brush Hill Road. An elegant Colonial Revival country estate with formal landscaped gardens, it was built in 1918 on a knoll overlooking Brush Hill Road. The house is a center entrance house with a hip roof, a heavy modillion cornice, and an entrance of paired Ionic columns. Robert Amory (1885–1972), for whom the house was built, was a textile manufacturer and copper dealer. His mother was Katherine Crehore Amory, a descendant of Teague Crehore of Milton. Today, the house is owned by Curry College and is used as the residence of the president.

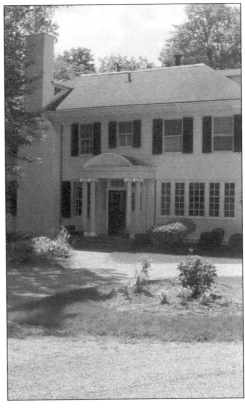

Cleveland Amory (1917–1998), the son of Robert and Leonore Cobb Amory, was born on Brush Hill Road in Milton. He was the author of *Who Killed Society?*, *The Last Resorts*, and *The Proper Bostonians*—three classics that chronicled the social history of a time gone by. A writer for the *Saturday Review* and editor of the *Celebrity Register*, Amory was coeditor of *Vanity Fair*, an anthology on that famous magazine. In later life, Amory was a leading animal rights advocate and wrote the perennially favorite book *The Cat Who Came for Christmas*.

The Pines, the estate of Henry S. Shaw, was at the junction of Hinckley and Allerton Roads. A large brick neo-Georgian house designed by Peabody and Stearns, the grounds were designed by Boston landscape architects Arnold & Punchard, who created a rustic garden with a center pool spanned by a bridge, a trellised vine-covered arbor, and a shelter that overlooked the landscaped grounds. The estate was later subdivided by William B. Crosby in the 1930s and marketed as the Columbine Rocks, a new development that was quickly built up with many well designed Tucker and Crosby houses. (Courtesy Milton Historical Society.)

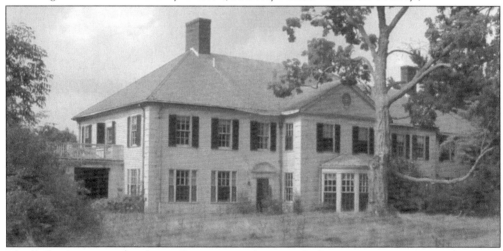

The Fuller Trust was on Blue Hill Avenue and was used after 1934 as a retirement home for many years. Thirty acres of the former Kennedy estate, including this house which was owned by Eliot T. Putnam, was purchased by the Fuller Trust to fulfill the desire of Caroline Weld Fuller (1863–1933). It offered "the comforts and care of a home for homeless women of refinement who for one reason or another found themselves invalid, penniless, or unhappy." Mrs. Fuller, who had been crippled in a riding accident, wanted this haven to be as homelike as possible. Although this house was demolished in 1999, Fuller Village is currently building luxury senior housing on its site.

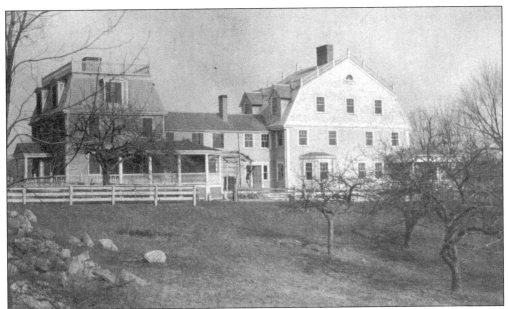

Elmbank is at 676 Brush Hill Road. Built c. 1810 by Ephriam Tufts, the Federal house was remodeled as a Colonial Revival summerhouse in 1903 by Joseph and Georgiana Hayward Whitney. Two massive gambrel-roofed additions were added to the original house. The front part of the old house was moved to 674 Brush Hill Road in 1934 and remodeled as a separate residence. On the property today is the Robert Tucker House. Called "the Centuries" by the family, this is the oldest house built in Milton, having been moved to this property in 1895 by the Whitneys. (Courtesy Samuel and Rosamond Whitney Carr.)

Joseph Cutler Whitney (1856–1911) was the son of Henry A. Whitney, president of the Providence Railroad. A trustee of estates and a principal in the wool business of Drake & Company, he served as a trustee of the Milton Public Library from 1888 to 1911. Whitney created an impressive country estate that extolled the virtues of the Colonial Revival, with a manor house, barn, and outbuildings and the quintessential feature—a real 17th-century house that created instant cache for the family compound. (Courtesy Milton Public Library.)

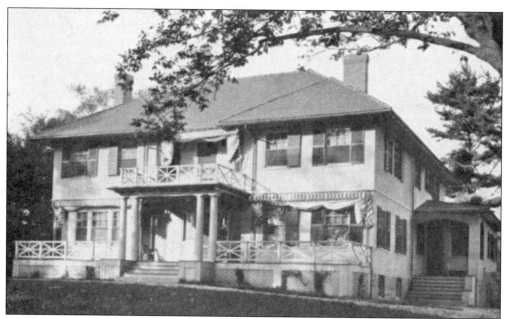

This impressive house was designed by Wales & Holt and built at 280 Adams Street for the noted suffragette Rose Dabney Forbes (1864–1947), the widow of J. Malcolm Forbes. Built on a part of the family estate known as Fredonia, which was named for one of the China Trade ships belonging to the Forbes family, the stucco house had a red ceramic tile hipped roof and classical balustrades. Influenced by the Craftsman style, the house has exaggerated overhanging eaves, an entrance flanked by fluted columns, and a roof balustrade. James A. Holt and George Canning Wales designed impressive Colonial and Craftsman houses until 1917, when Wales turned from architecture to etching and the partnership was dissolved. (Sammarco collection.)

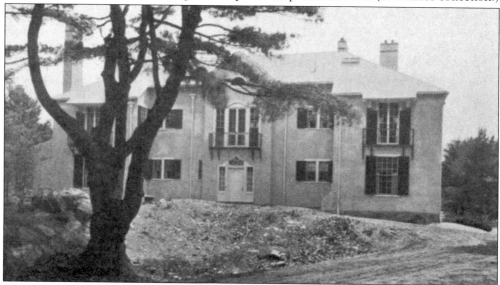

The Bigelow House was redesigned in 1899 by Henry Forbes Bigelow (1867–1929), a partner in the architectural firm of Winslow and Bigelow, and built by Bigelow & Mabie, as his summerhouse at 1073 Brush Hill Road. Bigelow created a stucco Italian villa from a c. 1870 house formerly owned by Felix and Julia Minot Rackemann. (Sammarco collection.)

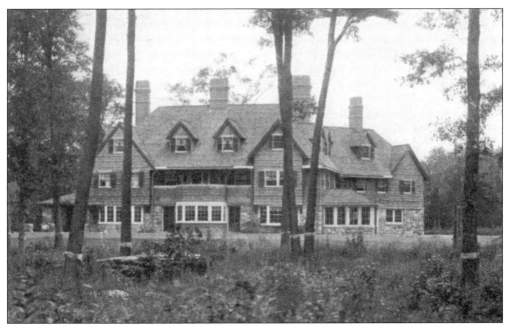

Joseph Brewer (1847–1938) owned this house at 650 Canton Avenue. It was designed by the noted architectural firm of Andrews, Jaques, and Rantoul. The massive house had both a drive façade with a porte cochere and a garden façade with banks of mullioned windows overlooking the grounds, which were designed by landscape architect Joseph H. Curtis. The massive brick chimneys punctuate the dormered roof, lending this Shingle-style house a post-Medieval quality. (Sammarco collection.)

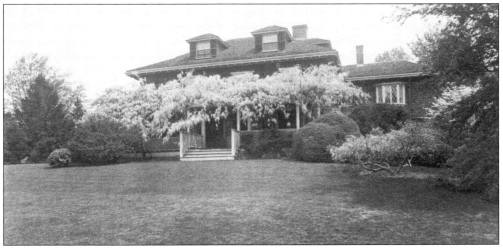

Jesse Bunton Baxter (1872–1954) built this Shingle-style house in 1912 at 175 Edge Hill Road in East Milton. The house had a low hipped roof with dormers and a bracketed cornice. However, one of the major attractions of the house was the lavish growth of wisteria, shown enveloping the house in this 1932 photograph. Baxter was president of the Blue Hill National Bank, then located at Associates Hall in Milton Village, and served as a selectman. The site of the house is now used as a community garden adjacent to Cunningham Park, of which Baxter was manager for 40 years and treasurer of the Cunningham Foundation. (Courtesy Milton Historical Society.)

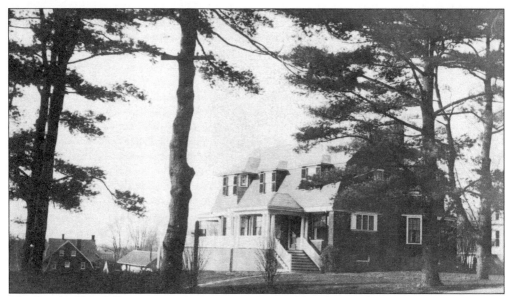

The Asaph Churchill House was built in 1891 by local builder Frank M. Morton, successor to Frederick Severance, at the corner of Randolph Avenue and North Russell Street. A large Shingle-style house with a massive gambrel roof and hooded dormers, it has post-Medieval details espoused by the Shingle style of suburban architecture. (Courtesy Milton Historical Society.)

Asaph Churchill (1814–1892) studied law at both his father's office as well as Harvard Law School, being admitted to the Norfolk County bar in 1834. A promoter of the Milton Branch of the Old Colony Railroad (now the surface trolley connecting Ashmont and Mattapan), a state senator, and president of the Blue Hill National Bank, he was a well-respected citizen. A resident of Dorchester from 1838 to 1891, his Dorchester house was designed by Luther Briggs Jr. and stood on the present site of the Carney Hospital. He had a house built in 1891 at 97 Randolph Avenue in Milton.

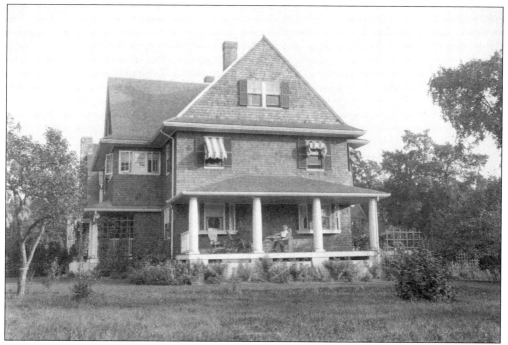

Architect Edwin J. Lewis Jr. designed Kingfield in 1911 for Mrs. William Cranch Bond Fifield and her daughter, Mary Fifield King, who is seated on the side porch. Built on land subdivided in 1900 from the Morton-Safford Estate, the house was a large Shingle-style house with bold Tuscan columns framing the entrance as well as being used to create a colonnaded porch on the side. (Sammarco collection.)

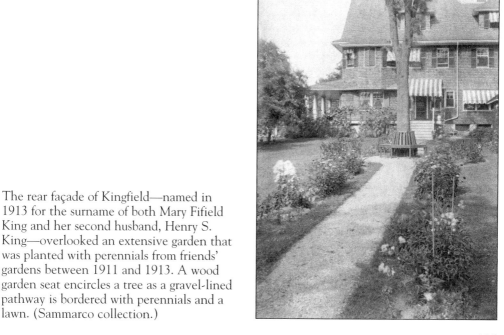

The rear façade of Kingfield—named in 1913 for the surname of both Mary Fifield King and her second husband, Henry S. King—overlooked an extensive garden that was planted with perennials from friends' gardens between 1911 and 1913. A wood garden seat encircles a tree as a gravel-lined pathway is bordered with perennials and a lawn. (Sammarco collection.)

Edwin J. Lewis Jr. (1859–1937) graduated in 1881 from the Massachusetts Institute of Technology and was associated with the architectural firm of Peabody & Stearns from 1881 to 1887, when he established his own practice at 9 Park Street in Boston. For five decades, Lewis was an important architect who designed not just Shingle-style suburban residences, but more than 35 churches in the United States and Canada. He was a devout Unitarian, and all but one of his churches were built for Unitarian congregations. Many of his residential designs were for friends. Lewis and his sisters, Marion and Bertha Lewis, moved from Dorchester to 121 Canton Avenue in 1923. Remarkably, Edwin Lewis never lived in a house of his own design. (Sammarco collection.)

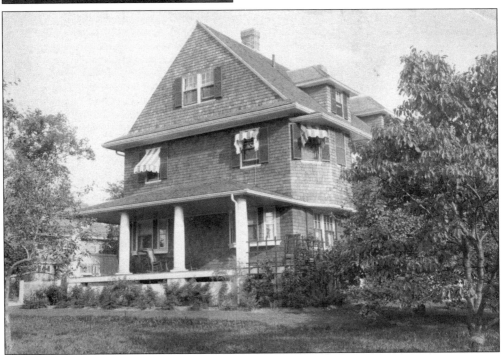

Kingfield was one of three Edwin J. Lewis Jr. houses that were built on land subdivided in the early 20th century from the Morton-Safford Estate: Kingfield, built at 77 Morton Road in 1911; the Hayward-Gilbert House, built at 86 Morton Road in 1910; and the Brooks-Larkin House, built at 87 Morton Road in 1912. The Hayward-Gilbert House can be seen on the left. (Sammarco collection.)

Nine
POST–WORLD WAR I
ARCHITECTURE

Although Milton continued to see architect-designed houses between 1918 and 1950, many houses were built by builders and developers who specialized in the subdivision of land for multiple dwellings. As said in *Three Hundred Years of Milton, 1662–1962*, the "really great change came to Milton after 1929, when the shadow of the coming depression began to be seen. Soon some of the larger estates became available to the speculative builder, and . . . Milton became largely a bedroom town for those who worked in Boston."

In this vein, Arthur H. Tucker & Son, a major building concern at Canton Avenue and Harland Street, built well-designed Colonial Revival houses throughout Milton in the early 20th century. Often adapting designs from the Colonial and Federal periods, these houses were often more robust than the original design and convenient for modern-day life. In most cases, Tucker-designed houses were as pleasant as they were comfortable, but were in no way considered ostentatious. In Milton, the term "Crosby-built" means well-designed and attractive houses that were built by William H. Crosby and his son, William B. Crosby. Using Colonial Revival houses as examples, the Crosbys built houses for speculation on the former estates that were subdivided in the early 20th century. Other building concerns were the Horne Brothers, C.C. Fulton & Son, Malcolm A. LeFevre, and C.H. Chute.

With accessibility in Milton increased initially by the Mattapan Branch of the Old Colony Railroad (after 1929, the surface trolley between Ashmont Station and Mattapan) and streetcar lines, these speculative dwellings were both attractive and desirable to the emerging suburban middle class. In some cases, whole neighborhoods were created by the Crosbys: the Columbine area with Valley, Columbine, and Ridge Roads; the area of Coolidge Road, Sias Lane, and Meredith Circle; and the triangular area of Centre Street, Canton Avenue, and Vose's Lane. In 1913, town meeting banned the building of three-deckers, and a zoning ordinance enacted in 1926 allowed only single-family houses and regulated further expansion of business areas in town.

The architecture of the 1918–1950 period often embraced traditional styles, or the historicism of architecture. Henry-Russell Hitchcock said, "Architecture derives its sanctions from the traditions of the further past, although in fact its only real tradition is that of the preceding hundred years." Hopefully, other houses built in Milton will perpetuate the architectural "traditions of the further past" and draw from the rich architectural styles represented in Milton for their interpretations.

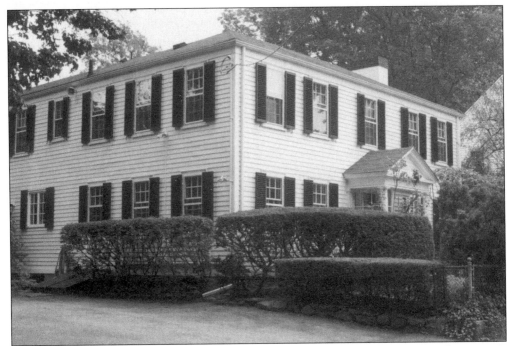

The Morse-Evans House at 40 Canton Avenue was designed by Eliot T. Putnam of Putnam & Chandler and built in 1921 on the site of the C.C. Holmes House. Built for Samuel A. Morse to resemble a Federal-style house, it has the size and scaling of an authentic house of its period, while having conveniences of the 20th century. The adjacent house, 50 Canton Avenue, was also designed by Eliot T. Putnam and built in 1924 for Dwight and Elmira Lee Evans.

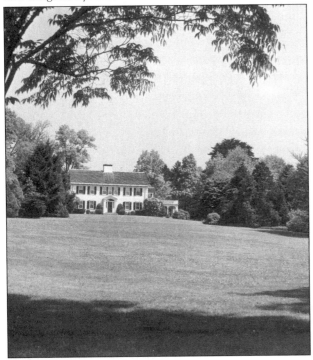

The George Thompson House is an impressive Colonial house that was designed by C.C. Fullerton and built in 1942 on the site of the Frothingham-Kidder House at 352 Adams Street. The house, set high on a knoll overlooking Adams Street, has the traditional design of a Colonial house, but has such differences as a bank of three windows above the front entrance and a squat center chimney (which, though correct, are incongruous to the overall design). A brick stable designed by William Ralph Emerson and built in 1880 for Henry Purkett Kidder survives on the property. (Courtesy Milton Historical Society.)

The Marden-Clifford House (66 Morton Road) was built by John A. Tucker & Son in 1931 for Charles Marden (1876–1949), publisher of *The Milton Record*. A well-designed Colonial Revival five-bay façade house with a gambrel roof, Tucker modeled this house on the historic Col. Lemuel Robinson Tavern, which was built c. 1760 on Washington Street in Dorchester. In 1769, the Robinson Tavern was the scene of a Sons of Liberty dinner, where after 59 toasts, the increasingly emboldened Sons proposed, "strong halters, firm blocks and sharp axes to all such as deserve either." Tucker's use of the old tavern's design for this house perpetuated its place in history. (Courtesy Edith G. Clifford.)

Arthur Holmes Tucker (1865–1930) was president of John A. Tucker & Son, a well-respected building firm established by his father, John Atherton Tucker, from 1897 to 1930. The Tucker Shop was at the corner of Canton Avenue and Harland Street (now H.C. Miller Woodworking). Tucker lived at 1016 Canton Avenue until 1917, when he moved to 126 Reedsdale Road. He was a selectman of Milton and a trustee of the Milton Public Library from 1902 until 1930. (Courtesy Milton Public Library.)

The Graton House was designed by Royal Barry Wills (1895–1962) and built in 1936 at 144 Adams Street on Milton Hill for L. Bowman and Catherine Hurd Graton. A Colonial Revival five-bay façade house, with an arched pediment surmounting the pilastered entrance, the home uses multipaned windows to add interest to an otherwise simple design. Royal Barry Wills graduated in 1918 from MIT, opening an office in 1925. He became a major proponent of the Colonial Revival, winning a gold medal in 1932 from Pres. Herbert Hoover in the Better Homes in America Small House Competition. He designed at least five houses in Milton. The Granton House replaced the Glover-Faucon House, which had been demolished in 1935.

The Edmond L'Ecuyer House was built by J.G. Morley, a local builder and developer, in 1938 at 195 Williams Avenue. A center-entrance Garrison Colonial with a projecting second story and a dentilled cornice, the use of flat stone veneer on the first floor and wood clapboards above adds interest to the overall design of the house. The transom side-lighted entrance is flanked by symmetrical multipaned bay windows. The house was built on land sold by the Tucker family, with Williams and Dana Streets being laid out in 1919.

Eleanor Raymond designed the Stackpole-Pierce House at 56 Morton Road as a retirement home for the widow of Markham Stackpole, a former educator at Milton Academy. Designed in 1948 by Raymond in the International style, it has a flat roof design with horizontal and vertical planks laid flat, a projecting roof over the front entrance, and an open living space plan that is in marked contrast to the more traditional houses built in the neighborhood.

Eleanor Raymond (1891–1989) was said to be an architect whose work "has been noted for its innovative design, use of materials and new technologies and environmental concerns." A 1909 graduate of Wellesley College, she later studied at the Cambridge School of Architecture and Landscape Architecture. She opened an office with Henry A. Frost in 1919, later practicing independently from 1928 to 1973. A fellow of the American Institute of Architects, her interpretation of the International style was represented in Milton in the Stackpole-Pierce House (1948), the Wigglesworth House (1936 renovations), and the Safford House. (Courtesy Frances Loeb Library, Harvard Design School with thanks to Mary Daniels.)

The Bradley House was designed by John Freeman Bradley as his private residence in 1940 at 76 Robbins Street. A five-bay Colonial with a pedimented entrance with pilasters flanking the entrance, the house has a hip roof and classical details that imitate those of the early 19th century. Bradlee, a graduate of Harvard and MIT, was a partner in the architectural firm of Leland, Larsen, Bradley, & Hibbard. In 1940, he married Junia Mason, the niece of Mrs. Holden McGinley, whose estate was on Blue Hill Avenue. The design for this house was reused by Bradlee for Cornelia Wolcott Drury, building for her an identical house at 1702 Canton Avenue in Milton. Interestingly, the Bradley House was later the home of noted opera singer Beverly Sills in the 1960s.

The Campbell House was designed by the architect Jerome Bailey Foster and built in 1950 at 308 Hillside Street. A traditional Cape Cod–style house with wood clapboarding and a roof of varying heights, the house was built for engineer James F. Campbell in the area known as Scott's Woods, still one of the most rural areas of Milton. Set on a large piece of land with a stone wall bordering the street, it complimented, while maintaining, the siting style of earlier houses along the street. Foster won an award in *House Beautiful*'s Small House Competition.

Ten

THE BLUE HILL
OBSERVATORY

The Blue Hill Meteorological Observatory in Milton surmounts a 635-foot hill, the highest of the Blue Hills. Opened in 1885 by Abbott Lawrence Rotch (1862–1912), a graduate of MIT, the observatory was among the first in this country to study the upper air through the use of clouds, kites, and weather balloons. Rotch, the son of Benjamin Smith Rotch (whose country house was on Blue Hills Parkway), was well known in Milton. His weather experiments brought curious visitors to the top of Great Blue Hill on foot, bicycle, and carriage. During the early years, kites were adapted to hold instruments that recorded temperature, wind direction, and velocity. They were often flown up to 3 miles into the air from the summit. In 1895, a camera was flown in a specially fitted kite, and a photograph of Great Blue Hill was taken. These kites, flown both singly and in groups, were attached to steel piano wire, which often snapped, causing problems as it was dragged across power lines and railroad tracks by the escaping kites. Rotch remained undaunted by these mishaps and continued his quest to gather scientific data.

Rotch operated his observation station with the assistance of a small staff until his untimely death. The weather station might have closed to further study, but his will endowed the observatory with $50,000, and his widow, Margaret Anderson Rotch, continued to provide necessary funding. The station was bequeathed to Harvard University and in this second phase of its history, it became a leading provider of information in the problem of forecasting storms, in cooperation with the Boston Weather Bureau. The dissemination of information, initially through newspapers and later through radio, continues to assists the Metropolitan District Commission and the Milton Highway Department.

Radio contact began in 1940 and was later augmented by the call letters WGBH-FM. Interestingly, the call letters GBH, used by our PBS station, Channel 2, stand for Great Blue Hill. Rotch's vision is still maintained to this day. Abbott Lawrence Rotch once said that the observatory would ultimately be used in "the investigation of the rainfall at this elevation, the velocity and direction of the wind, the maximum and minimum temperatures, the paths of thunder and other storms and such other phenomena as may present themselves." The Blue Hill Meteorological Observatory still maintains a legacy of continuous and detailed information of the weather since 1884.

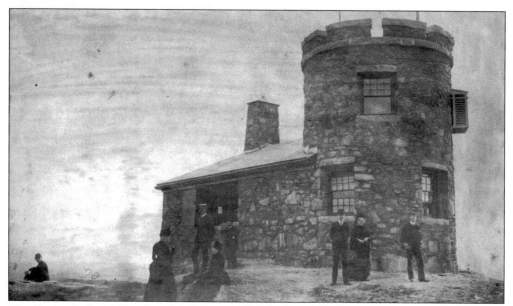

Mrs. Benjamin Smith Rotch and A. Lawrence Rotch (beneath the tower window) pose with their friends outside the recently completed Blue Hill Observatory in 1885. Abbott Lawrence Rotch purchased an acre of land on the south side of Blue Hill and "with difficulty obtained a small lot including the highest point on the hill." The observatory was commenced in 1884 and opened on January 31, 1885. The crenellated tower had a one-story, hip-roofed house with 20-inch-thick walls. The house had two bedrooms, a dining room, and kitchen. (Sammarco collection.)

Abbott Lawrence Rotch (1861–1912) is considered the "Father of American Meteorology." A pioneer in the exploration of the upper air, he maintained the Blue Hill Observatory at his own expense. In 1906, he became professor of meteorology at Harvard University, the first such chair in this country. Before his marriage, Rotch lived in a house he built at the junction of Canton and Blue Hill Avenue and Brush Road. He later purchased an estate on Canton Avenue adjacent to that of the Hemenway family, although he lived at 182 Beacon Street in Boston's Back Bay. Rotch was named chevalier in the French Legion d'Honneur, and was awarded two Prussian orders for his experiments.

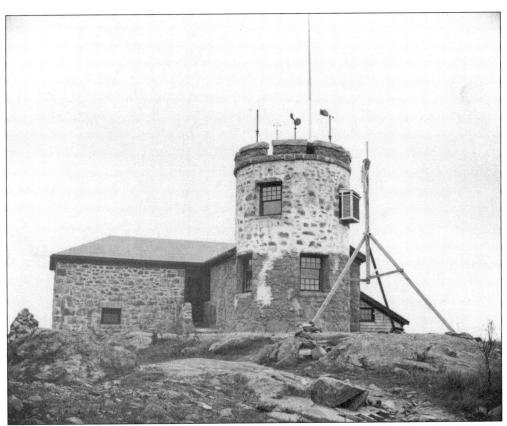

The Blue Hill Observatory was designed by the noted architectural firm of Rotch and Tilden and built by J.H. Burt & Company as a rough stone structure with a two-story crenellated tower, which had instruments projecting above the ledge that were connected to recording devices inside the observatory. Arthur Rotch (1850–1894), a partner in the architectural firm of Rotch and Tilden, was a brother of Abbott Lawrence Rotch. Following Rotch's death in 1912, he bequeathed the observatory to Harvard University with an endowment so that it would continue his vision. (Courtesy Milton Historical Society.)

Abbott Lawrence Rotch (center) watches as a weather balloon ascends with a recording instrument attached by a wire. These instruments made the first accurately recorded cloud height and velocity measurements, vertical motions of air, and the behavior of the upper strata. A plaque at the observatory states that Rotch's was "a life devoted to science for the good of Mankind." (Courtesy Milton Historical Society.)

The staff of the observatory poses in 1891 in front of the stone tower. Shown, from left to right, are Henry Helm Clayton, Sterling Price Fergusson, Alexander G. McAdie, Abbott Lawrence Rotch, and A. Kendrick. Not shown is the beloved observatory mascot, Alp, a St. Bernard who was a true weather dog. (Courtesy Milton Historical Society.)

Posing at the base of a tripod are observatory workers Sterling Price Fergusson and Alexander G. McAdie. (Courtesy Milton Historical Society.)

*Soft, rounded hills, that to my
youthful eyes
Stood as Titan guards to Paradise.*

Henry Helm Clayton (1861–1946) poses on a high wheel bicycle at the base of the Blue Hills at Canton Avenue c. 1888. An avid meteorologist, Clayton succeeded Willard P. Gerrish, who was the first observer and had set up the recording instruments. Clayton's "study of the air has been largely through cloud movements, but there have also been some most interesting observations by means of kites to which recording instruments have been attached." In 1906, he left the observatory to become chief of the U.S. Weather Bureau in Washington, D.C. His study of the clouds yielded the first definite information concerning the circulation of atmosphere over America and established the Clayton Engell Law of the increase of velocity with height. (Courtesy Milton Historical Society.)

Abbott Lawrence Rotch holds a piano wire attached to a box kite held by Henry Helm Clayton. From the summit of Great Blue Hill, the first recording instruments were carried by kites on a piano wire and were sent aloft to heights as great as 3 miles. (Courtesy Milton Historical Society.)

The Milton lockup was built in 1884 and was located on Wharf Street at the Town Landing in Milton Village. With a superintendent's office and five cells, it served as the police headquarters and jail until it closed 1906. Lined up in front of headquarters in 1900 are Milton's finest. Notice the iron bars on the window on the left. The one-story red brick and granite building, built by J.H. Burt & Company, is now used as the headquarters of the Milton Yacht Club. (Courtesy Milton Historical Society.)

Acknowledgements

We would like to thank sincerely the board of the Milton Historical Society and the trustees of the Milton Public Library for their generosity in the loaning of the majority of the photographs for use in this book on Milton architecture. Contemporary photographs were taken by the authors.

We would also like to extend our sincere thanks to the following: Anthony Bognanno; the Blue Hill Meteorological Observatory; Helen Buchanan; Paul Buchanan, president of the Milton Historical Society; Samuel and Rosamond Whitney Carr; Nicholas S.F. Carter; Janice Chadbourne, Fine Arts, Boston Public Library; Edith G. Clifford; Glenn Coffman, director of the Milton Public Library; Lorna Condon, Society for the Preservation of New England Antiquities; John Cronin, Milton town administrator; Martha T. Curtis; Mary F. Daniels, Special Collections, Frances Loeb Library, Harvard Design School; Dexter; Kevin C. Donahue; Edward L. Duffy; Joan Estelle Evans; Frances Pierce Field; First Parish in Milton, Unitarian, Rev. Laurie Bilyeau; Robert Bennet Forbes House Museum, Christine Sullivan, director; John B. Fox; Roger L. Gregg; Dr. Ward I. and Barbara Gregg; Dan Hacker, Milton Public Library; Peter Hanson and Joan Halpert; Virginia A. Holbrook; William Morris Hunt; James Z. Kyprianos; Nadine A. Leary; Joseph LoPiccolo; William Loughran; Judith McGillicuddy; trustees and staff of the Milton Public Library; James G. Mullen, Milton town clerk; Joseph J. O'Neill; Evelyn O'Sullivan; Susan W. Paine; the Perkins family; Jeannette Lithgow Peverly; Margaret Recanzone; Robert and Hannah Ayer Saltonstall; Anthony and Mary Mitchell Sammarco; Sylvia Sandeen; Amy Sutton, our editor; Jeanne M. Sutton; Judith B. Tankard; Anne and George Thompson; Carolyn D. Thornton; John Avery Tucker; William Varrell; Frances K. Westerbeke, chair, Milton Historical Commission; Fran Westhaver; Barbara White; the White House Historical Association; and the late Norman Whiting.